A History of

NATIVE
AMERICAN

LAND RIGHTS

—— IN ——

UPSTATE NEW YORK

CINDY AMRHEIN

A History of
NATIVE
AMERICAN
LAND RIGHTS
IN
UPSTATE NEW YORK

THE
History
PRESS

Published by The History Press
Charleston, SC
www.historypress.net

Cover image: *Dreams of No Flight*, by Frank Vando.

First published 2016

Manufactured in the United States

ISBN 978.1.62619.931.6

Library of Congress Control Number: 2015955229

Notice: The information in this book is true and complete to the best of our knowledge. It is offered without guarantee on the part of the author or The History Press. The author and The History Press disclaim all liability in connection with the use of this book.

In memory of
Henry Lloyd Jacobs,
whose wisdom and friendship
I greatly miss.
1946–2008
Seneca-Hawk Clan

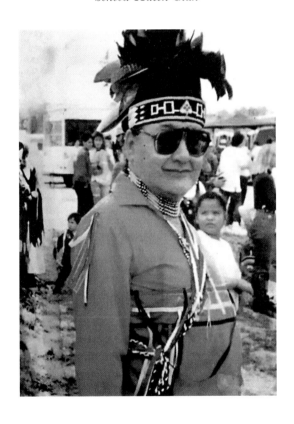

CONTENTS

Contents

PREFACE

I've always enjoyed the local history of my state, and in 1997, I was appointed the historian for the town of Alabama in Genesee County, New York (a position I held until 2007, when I became the assistant Wyoming County historian; as of this year, I am the county historian). With a large portion of the Tonawanda Band of Senecas' reservation geographically within the town of Alabama's borders, I took an interest in documenting some of the history of the Tonawanda Senecas. It was by accident that I began to write in 2004 for a Native American newspaper called the *Akwesasne Phoenix Sundays* in northern New York near the St. Regis reservation.

By this time, I had already been a freelance abstractor for a number of years. An abstractor is a person who does an abstract of title for a piece of property. If you have ever bought or sold a house or taken out a mortgage, either your realtor or attorney has contacted an abstract company and requested a title search to make sure it is free of any debts or encumbrances to clear title. The bank requires this to protect its interest so someone can't come along later and claim a right to it.

I have researched land titles for abstract companies, attorneys, private parties wishing to put their home on the National Register of Historic Places and for my own pleasure. I have done title work in every county in Western New York, as well as Clinton, Franklin and St. Lawrence Counties in the northern part of the state. I have even helped—remotely from my computer—with a title search for land in Alaska (where the index to records is online) and Vermont. Combining my skills as an abstractor and

my historian's obsession to document facts, I found my niche in researching Indian land titles from an abstractor's point of view—hence the subject of this book.

Through one contact to another, I began speaking to groups of traditionalists from different Indian nations in New York—regular folks who were interested in keeping their culture and land intact. Like the rest of the country, their people didn't always agree with the choices their governments made. Since I was willing to share what I learned, I was eventually put in contact with the owner and editor of the *Akwesasne Phoenix Sundays*.

The first story I wrote was a tongue-in-cheek political commentary on Governor Pataki and the casino deals for land claims going on in the state at the time. Since my opinions were my own as a citizen with the right to free speech and not related to my duties as an abstractor or historian, I began writing on a regular basis a weekly editorial column under the pen name of "the History Sleuth."

Unfortunately, the *Phoenix* went out of print in July 2006. Although some of my editorials over those two years were political opinions or satire, the majority were on the history of Indian land titles in New York through the eyes of an abstractor. Since I still receive requests for information on the subject to this day, I decided to compile some of the articles and adapt them to book form.

I often use the word "Indians" when I write, although I'm told by non-Indians that it is more politically correct to say "Native Americans" or "First Peoples," which seem to be the latest terms. However, the Native Americans I know prefer the word "Indian" because that is what the treaties say, so that is the term I use. Their concern is that once other words start being used, the day may come when the Indian people will be told, "We made the treaties with the Indians, and you are not an Indian, you're a Native *American*." That is how seriously they view the wording in their treaties after centuries of having them broken. Their insight into all of this has been an educational journey in itself, and I appreciate the information that has been shared with me.

Although this book is a reprint of the newspaper articles, I have expanded and added citations that are not possible in the limited space of a newspaper. All of it is public information. Any land claim cases were looked up online on *Lois Law*, *Find Law* and *JUSTIA US Law*, or I was given a copy of the case itself. Deeds, of course, came from the various county clerks' offices. Laws and acts of New York were either found at the New York State Library, among old law books at various repositories or published in newspapers from the

period. The Library of Congress has the collection of *American State Papers, 1789–1838,* maps, letters and other documents. Also used was Kappler's *Indian Affairs: Laws and Treaties* (1904), which can now be found online at http://digital.library.okstate.edu/kappler. David Rumsey's Historical Map Collection is another valuable resource and can be found online at http://www.davidrumsey.com.

There is an excellent microfilm collection that I am fortunate to be able to access at SUNY–Geneseo College's Millen Library called *Iroquois Indians: A Documentary History of the Diplomacy of the Six Nations and Their League.* It contains fifty reels of microfilm, covering 1666 to 1842. It consists of copies of handwritten documents, treaties, speeches, letters and minutes of treaty meetings that were gathered from the collections of several countries and put in chronological order. I also gathered information from historical newspapers, either on microfilm or digitized and available on the Internet. I can't begin to count the hundreds of hours I have sat in front of a reader/printer somewhere until my eyes were buggy.

Of course, in all of this, there is also my own personal collection to rely on. It is my hope that you, the reader, will find this book an opportunity to look at the history of Indian nations in New York from a fresh perspective and hopefully research some of these events and documents for yourself.

ACKNOWLEDGEMENTS

Many thanks to Gloria Warrior—my sister in my heart—for being my friend, traveling companion and research assistant; Edna Gordon for her unique perspective on life; Doris Bannister for her knowledgeable input; Audrey Eberstein for her critical eye; my good friends Giniti Harcum El Bey and Lokerononh for being my guides in St. Regis; my husband, Jody, for his support and willingness to go on road trips at the spur of the moment; and Frank Vando and Kim Hathaway of the *Akwesasne Phoenix Sundays* for giving me the opportunity to write.

Introduction
SOVEREIGNTY

Under federal Indian law, there are special statutes that apply just to the Indian nations of New York State. Why is that? It is because the nations of New York do not have their reservations held in trust by the government. This fact is very important and should not be forgotten. This is true sovereignty. Despite any treaties, agreements or what are now instead called "compacts," the Indian nations geographically located within New York State are standing on the same dirt they stood on before the arrival of the Europeans.

Many of the other tribes in the eastern part of this country were removed from their original lands and displaced west of the Mississippi. This created, in European and American terms, a change of land title. The land went from one sovereign government, an Indian nation, into the hands of another sovereign government: the United States. A different piece of land was then allotted to a tribe in the form of a reservation, with conditions placed on the conveyance, to be held in trust for it by the United States. A nation that puts its land in trust will forever be under the thumb of the government. This is not what happened in New York. As New Yorkers well know, the Six Nations never left.

There was no confusion by the British, French and, later, the Americans as to who owned the land in what would eventually become the State of New York (minus the reservations). It is printed very clearly on all the maps of early exploration as "Country of the Five [or Six] Nations" or "Territory of the Iroquois." In maps as early as the 1600s—whether they are in the

language of French, Dutch, Italian, German or British mapmakers—the villages of the five Indian nations (later six) are clearly identified. In the 1656 map by Francesco Bressani, an Italian missionary to the Huron, the territory of the Iroquois—or "Hirochiii," as he has marked it—is indicated on his map. Although slightly askew, the Hudson and Mohawk Rivers to the right are plainly drawn with a very nice illustration of the Mohawk settlements.[1] You will see each nation is indicated, as well as Lake Erie and Lake Ontario.

A German mapmaker, Wolfgang William Römer, who received his engineer training with the Dutch and later worked for the British, drew a very detailed map in 1700 called *A Mappe of Colonel Romers Voyage to ye 5 Indian Nations*. Aside from fur traders and miscellaneous accounts of exploration, no one had thoroughly explored the area in the western part of the state before this time. A reprint of the map would not do it justice. You can find a digital image at the website of the State University of New York at Stony Brook.[2] The Indian villages are named and indicated by a longhouse.

In the 1718 map titled *Louisiane, Cours du Mississipi*, by Guillaume DeLisle, which was published in Paris, the territory of the Iroquois is clearly indicated. Thick lines to the right on the map indicate the boundaries between the Indian nations and what was then New York, Pennsylvania and Maryland.

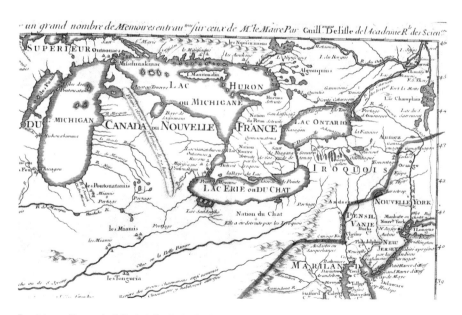

Louisiane, Cours du Mississipi, 1718. *David Rumsey's Map Collection.*

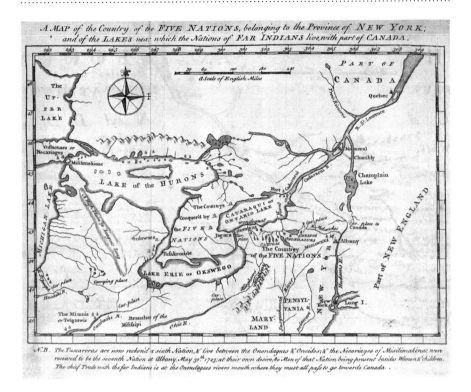

Map of the country of the Five Nations. *Frontispiece to* Colden's History. *Library of Congress.*

A map was attached to New York governor Cadwallader Colden's book *The History of the Five Indian Nations of Canada which Are Dependent on the Providence of New-York in America*, printed in London in 1747. The map plainly states "The Country of the Five Nations" because they were viewed as nations within their own country.

The map made in Albany on March 7, 1788, created just prior to New York becoming part of the United States on July 26, shows the townships and the approximate "country" of each of the Five Nations. At that time, New York did not look the way it does today (although it is erroneously depicted as such in most school textbooks). New York as a state, with its few eastern counties, also included Vermont. In 1790, Vermont broke away to form its own state. It is very clear on New York's own map that the "countries" of the Five Nations (six including Tuscaroras) occupied much of New York and stretched from Pennsylvania to Canada.

The particular wording in treaties is often dismissed as standard legal jargon. However, every word should be analyzed. Despite the fact that

Map of the State of New York as defined by stature on March 7, 1788. *New York State Archives.*

treaties, by law, are to be interpreted liberally in favor of the Indians and the way they would have understood them, this is not always the case when a land claim goes to court. It is often implied that treaties were only created to pacify the tribes to keep the peace.

This attitude, in my opinion, is historically inaccurate. The word "nation" appears in the treaties because the Iroquois were treated as such. If they weren't considered a force to be reckoned with, they would have suffered the same fate as other tribes did at the hands of early explorers—enslaved or driven out. Both the French and the British dealt with the Iroquois Confederacy just as they did any other foreign power. In fact, it is commonly accepted now that, upon its independence, the United States adopted aspects of the Iroquois form of government.

It is true that treaties were conducted partly to keep the peace, just as any other foreign peace treaty, or for the mutual return of prisoners. They also were made to lay claim to the ruling jurisdiction of the land, again like any other treaty between different governments. It is my belief that treaties in themselves do not convey land. I base this on my experience with land issues as an abstractor.

From maps drawn by the Europeans themselves and treaties entered into with the Iroquois Nations as a framework for a government-to-government relationship, it is clear the Europeans understood the territory of the tribes to be the *country* of the Five Nations. Even the 1768 Fort Stanwix treaty with the British, which attempted to establish the line between the whites and the Indians, clearly states, "The lands occupied by the Mohocks around their villages, as well as by any other nation affected by this cession, may effectively remain to them and to their posterity."

Not only did these foreign European powers bring with them their protocol of dealing with other nations, but they also brought to America the European standard method of conveying land. At first, this was done by land patents and, later, by indentures or deeds (the documents that prove "American" ownership to land).

Treaties did not convey the actual land; only a deed does that. They did, in some cases, convey preemptive rights to the land. This can be compared in modern terms as a "buyer's first rights" or "option to buy" agreements, which are still in use today. Basically, it works as follows: Person 1 has land that Person 2 wants. Person 1 says he doesn't want to sell it. They discuss terms and decide to enter into a written agreement. *If* and *when* Person 1 wishes to sell his land, he has to give Person 2 the first shot at buying it. The same principal was applied to Indian land and called "preemptive rights." Sometimes it is spelled out more clearly as "until they choose to sell the same to the people of the United States, who have the right to purchase."

Massachusetts and New York had argued since before the Revolutionary War as to which state held the rights to the physical land itself in what would later become Western New York. In 1786, representatives from Massachusetts and New York signed an agreement in Hartford, Connecticut, that New York would hold the governing rights to the land and Massachusetts would own the preemptive rights to the land itself, "subject to the rights of the Indians."

With the deal in place between New York and Massachusetts, the states next needed to file the document in the land records so there would be no confusion as to which state owned the preemptive rights to the land. This document is filed in many Western New York counties (if not all) in order to show what is called the "chain of title." It has to be filed because it is the legal proof of the land agreement needed in order to show clear title. For example, it is filed in Erie County in Liber 26, page 469 of deeds, and in Niagara County in Liber 11, page 555 of deeds. I obtained my copy from the Massachusetts Archives.

In any treaty involving a possible shift in preemptive rights or in an outright sale, Massachusetts was to have someone present at the treaty signing because it held the buyer's first rights to the land if the Indians chose to sell it—the actual dirt itself. A representative from Massachusetts had to be there to sign any documents that conveyed the state's preemptive rights to the buyer. This is a very important point that is often overlooked. New York only had governing rights over its own people, per the Hartford Compact. It held no ownership rights to the land or rights to control the Indian nations' people on the land. New York also had no rights to buy from the Indians without consent from Massachusetts and its chosen representative present. Any land claims should really go before Massachusetts, not New York, because New York never held the right to the physical land itself, only the right to govern its *own* people on the land that the Indians chose to sell.

Many of the treaties included the wording "excepting and reserving," which means "I give you first right to buy parcel A, if I choose to sell, *except* the village, which is *reserved* for my people." Party 2 could also sell its preemptive rights to another; often these rights were sold to land companies. Still, the Americans used the same system as the Europeans to convey land. In order for the title to be transferred, a deed needed to be filed in the county where the land was situated. Through my research, I have found there are deeds that correspond to some of the treaties. For example, there are five deeds for the Tuscaroras reservation, a deed for the Cattaraugus (based on the 1797 Big Tree Treaty) and a deed for the Tonawandas (based on the treaty of 1857).

Following the standard methods and laws pertaining to land conveyance, if there is no deed, the land should not be considered transferred per the treaty. For example, there is no deed filed in the Erie or Niagara Counties clerk's offices showing that the Seneca ever conveyed Grand Island in 1815. In my opinion, despite the treaty (purchase agreement), the Seneca never signed a deed to complete the transaction.

I will now try to illustrate exactly what all of this means to the Indian nations of New York as it relates to true sovereignty. You will need a piece of chalk, a parking lot and two people to do the experiment. Party 1 should draw a large circle in the parking lot and then stand in the middle of the circle and not move. The circle will represent, for the sake of the experiment, the aboriginal territory of an Indian nation, with what is now New York State around it. Party 1, standing in the middle, will represent the leaders of said Indian nation. That party is standing inside the nation's sovereign country. It is the same land his people have stood on since time immemorial—before

the arrival of the Europeans (be they Dutch, French or English). Since no title to the land has ever been passed where Party 1 is standing, it is still a separate nation. Party 2 will represent any one of the many land mongers, be they private or governmental. Party 2 (land monger) wants to purchase land from Party 1, the Indian nation. Party 2 draws a circle three feet from the *inside* edge of the larger circle. The three-foot-wide circular strip on the inside edge will represent what Party 2 wants to buy. Party 1 does not wish to sell. The two enter into a treaty for preemptive rights to the land. If Party 1 ever changes his mind, he has to give Party 2 the first shot at buying the land for the agreed-upon price. As mentioned earlier, in real estate terms, this is referred to as "buyer's first rights," which may or may not have a dollar amount attached, or an "option to buy." A recent example of a land option agreement would be one of the several wind turbine companies around New York State that entered into option agreements with land owners while they decided if it was feasible or not to purchase (or lease) the land to erect a wind farm.

Let's say Party 1 (Indian nation) eventually decides (or is coerced) to sell a piece of his nation's land. In our example, that is the three-foot-wide piece inside the circle. The words in the deed should follow the words in the treaty. So for our example, the deed describes the entire circle owned by Party 1 *"excepting and reserving"* the inner circle. Pay attention to the fact that Party 1 has not moved from his original spot. In other words, the inner circle he is standing on is still his own sovereign land. The status of the inner circle he is standing on has never changed title. It is still the same separate country it was before the Europeans arrived and began dividing up the territory. Rather than to say the Indian nations are within the State of New York, it is more accurate to say that New York state surrounds the individual Indian nations. New York borders the Indian nations the same as it borders the nation of Canada. The inner circle is called a "reservation" because it was excepted out of the land deal and "reserved" for the tribes preserving the land in its original state. This is not what happened elsewhere in the country.

New York was the grand experiment of what not to do if one wanted to take Indian land. The lesson the federal government learned was not to negotiate treaties with the Indian tribes in the same manner it had in New York. The United States learned it was far easier to bribe a few Indians who were willing to sign, whether or not they were chiefs; forcefully remove them from their own territory; and give them land elsewhere that had been taken from some other Indian tribe. By taking the land, the new owner (the federal government) then reallocated it to another

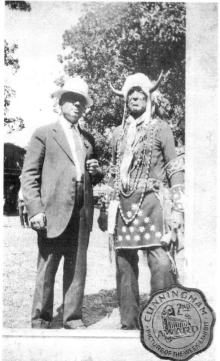

Above: Cook family, Raquette Point Road, circa 1900. *Starting fourth from left*: Jake Cook (Jake-O-Bear), Margaret Sharrow, Christie Cook, Mitchell Philips, Mary Cook, unidentified and Paul Cook. *Akwesasne Cultural Center.*

Left: Pictured on the left is Alex White, grandfather of Sue Herne, curator of the Akwesasne Cultural Center, circa 1940s. *Sue Herne.*

tribe with stipulations attached to its use—the "holding it in trust" for the tribe. Displacement from one's own region of the country was intentional, as was putting Indian nations from different regions together without knowing if they could coexist. This was done by design—divide and conquer. It is easier to control a group if you can prevent their unity. Toss them together and hope they will fight among themselves.

Because of the way tribes within New York were dealt with in the past, they proved to be obstinate opponents to President Andrew Jackson's Indian Removal Act of 1830. What is commonly called a reservation in New York State is, and has always been, a separate country. That land has never changed hands from the people of that nation. It was reserved to them and not included in any sales, thus preserving their chain of title. This is an important point, as the Indian nations geographically inside the borders of New York should be considered sovereign nations and neighbors to the United States.

PART I

...

The Treaties Between the
ST. REGIS
INDIANS
AND THE
STATE OF NEW YORK,
1816-1845

1

THE MACOMB PURCHASE

In 1787, John Livingston, Colonel John Butler, Samuel Street, Captain Powell and Lieutenant William Johnston tried to purchase a 999-year lease for about 8 million acres from the Six Nations. The New York and Massachusetts legislatures, as well as the new United States government, immediately declared this lease void. As governments, they had already entered into an agreement in Hartford, Connecticut, the year before. These few individuals were not going to be allowed by New York or Massachusetts to reap extensive profits from so large a chunk of land. The United States was also opposed. There was to be no interference from private parties, or the states, for Indian land without approval from the United States. Livingston's lease had been entered into without the federal government's previous knowledge. New York and Massachusetts objected because they were already in negotiations with Oliver Phelps and Nathaniel Gorham, as well as other investors, for the purchase of the western half of what would be included in the State of New York. The Livingston transaction is one of the major points that led to the Indian Nonintercourse Act of July 22, 1790. George Washington wrote:

To Alexander Hamilton, Secretary of the Treasury
Mount Vernon, 4 April 1791.

Dear Sir,
Your letter of the 27ᵗʰ ultimo came duly to hand. For the information given

in it, and for the notes which accompanied the same, I thank you. Every expedient, as I believe you know, is tried to avert a war with the hostile tribes of Indians, and to keep those who are in treaty with us in good humor; but I am almost thoroughly convinced, that neither will be effected, or, if effected, will be of short duration, whilst land-jobbing, and the disorderly conduct of our borderers, are suffered with impunity; and while the States individually are omitting no occasion to intermeddle in matters, which belong to the general government.

It is not more than four or five months since the Six Nations, or part of them, through the medium of Colonel Pickering, were assured, that henceforward they would be spoken to by the government of the United States only, and the same thing was repeated in strong terms to Cornplanter at Philadelphia afterwards. Now, as appears by the extract from Mr. King, the legislature of New York are going into some negotiations with these very people. What must this evince to them? Why, that we pursue no system and that there is no reliance on any of our declarations. To sum the whole up into a few words, the interference of States, and the speculations of individuals, will be the bane of all our public measures.[3]

George Washington also directed a letter to Cornplanter, a Seneca chief, on December 29 of that same year, which stated the following:

The general government only has the power to treat with the Indian nations, and any treaty formed and held without its authority will not be binding. Here then is the security for the remainder of your lands. No State nor person can purchase your lands unless at some public treaty held under the authority of the United States. The general government will never consent to your being defrauded; but it will protect you in all your just rights. Hear well, and let it be heard by every person in your nation, that the President of the United States declares, that the general government considers itself bound to protect you in all the lands secured to you by the treaty of Fort Stanwix, the 22d of October, 1784, excepting such parts as you may since have fairly sold to persons properly authorized to purchase of you. You complain, that John Livingston and Oliver Phelps have obtained your lands, assisted by Mr. Street of Niagara, and that they have not complied with their agreement. It appears, upon inquiry of the governor of New York, that John Livingston was not legally authorized to treat with you, and that every thing he did with you has been declared null and void; so that you may rest easy on that account. But it does not appear from any proofs yet in the possession of government, that

Oliver Phelps has defrauded you. If, however, you should have any just cause of complaint against him, and can make satisfactory proof thereof, the federal courts will be open to you for redress, as to all other persons. But your great object seems to be the security of your remaining lands, and I have therefore, upon this point, meant to be sufficiently strong and clear; that in future you cannot be defrauded of your lands; that you possess the right to sell, and the right of refusing to sell your lands; that, therefore, the sale of your lands in future will depend entirely upon yourselves; but that, when you may find it for your interest to sell any parts of your lands, the United States must be present by their agent, and will be your security that you shall not be defrauded in the bargain you may make.[4]

It is very clear from Washington's words that he wanted no interference from the states or backdoor deals going on that were unknown and without an agent from the federal government present. Despite the president's own words, in 1791, during a session of the New York state legislature, it was decided to encourage settlement in this vast "unclaimed" territory of New York. The land should be sold off as quickly as possible "in a manner as they should judge most conducive to the interest of the public,"[5] hence the appointment of land office commissioners, which consisted of Governor DeWitt Clinton, Secretary of State J.A. Scott, Attorney General Aaron Burr, Treasurer Girard Bancker and auditor Peter T. Curtenius. Over 5 million acres were "sold" in 1791. Here we need to question by what authority these transactions were initiated if the 8-million-acre deal by Livingston et al. had been declared void by all the governments involved. The state had, of course, voided Livingston's transaction because New York wanted to control the sale of the land and reap the profits.

Of the 5 million acres sold that year, 3,635,200 acres geographically in northern New York State were sold to Alexander Macomb (sometimes spelled McComb) for only eight pence (approximately eight cents) an acre. Large tracts were also sold to others but at higher prices. When the report of these sales appeared in the state assembly, the members were not pleased. One assemblyman, Colonel Talbot, felt the tracts were too large and found it suspicious that such a large tract was sold to Macomb for so little. The profits to the state would have been larger if the land had been sold in smaller tracts to a variety of buyers. He basically implied that the governor's friends secretly had interest in the sales. The commissioners denied any corruption. After much debate, a resolution was passed that approved the decisions of the commissioners.[6]

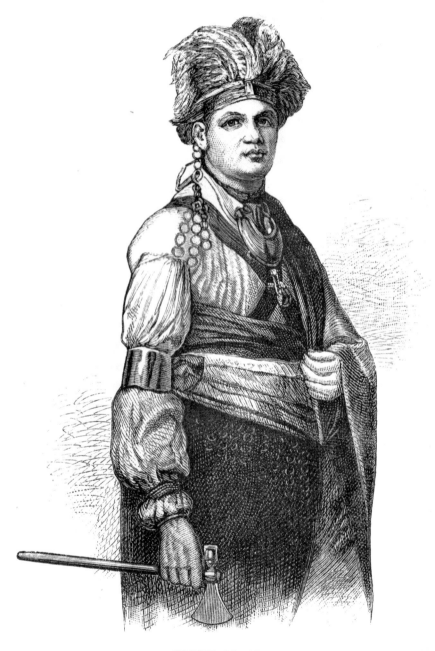

JOSEPH BRANT.

Joseph Brant. *From* Indian History for Young Folks *by Francis S. Drake.*

The St. Regis and Caughnawagas tried to assert claims to the New York state legislature between 1792 and 1794 but were ignored, at least in part because the state refused to accept that the Indians had any claim to the land. The state and United States government at the time were focusing their attention on other land held by the Six Nations in Western New York and were busy negotiating the Canandaigua Treaty, which was ultimately held in November 1794.

It was during this time that Joseph Brant and John Deserontyon allegedly negotiated away all the title to land held in New York State, including the Mohawk Valley. Brant had sided with the British in the Revolutionary War and had received a grant of land in Upper Canada. He had no interest in the land south of the St. Lawrence River; therefore, he had no objection to taking money to sign away the land in New York State. Mohawks on both sides of the border objected.

It is a common thing in contracts and deeds for one party to relinquish its rights, but it didn't mean the other parties in ownership had given up their land rights. Just because a few from Canada gave up their claim to land south of the border doesn't mean any of the Indian nations geographically in the United States did the same.

THE SEVEN NATIONS.
Communicated to the Senate, May 3, 1796
Gentleman of the Senate:

Sometime last year, Jeremiah Wadsworth was authorized to hold a treaty with the Cohnawaga Indians, styling themselves the Seven Nations of Canada, to enable the State of New York to extinguish, by purchase, a claim which the said Indians had set up to a parcel of land lying within that State. This negotiation having issued without effecting its object, and the State of New York having requested a renewal of the negotiation, and the Indians having come forward with an application on the same subject, I now nominate Jeremiah Wadsworth, to be a commissioner to hold a treaty with the Cohnawaga Indians, styling themselves the Seven Nations of Canada, for the purpose of enabling the State of New York to extinguish the aforesaid claim.

GEO. WASHINGTON.
United States, May 2, 1796.[7]

A treaty was arranged to be held on May 23, 1796, in New York City. Those who traveled to the city to represent the Seven Nations of Indians

residing in the State of New York and Upper and Lower Canada were Good Stream and Thomas Williams, two chiefs from Caughnawagas; Colonel Louis Cook, a chief of the St. Regis; and William Gray, who also served as interpreter. William Gray delivered a speech on behalf of the chiefs. In part, the speech stated they were granted full power to act on behalf of their nations and included the following:

> *Brothers:*
> *You brought in several objections to our claim, but we could not find either of them to be reasonable, or in any way sufficiently weighty, if we had ever sold any of our lands, either to the King of France or Great Britain, or either of the United States, we should have of course signed our names to the agreement, which if that were the case, we are sensible that such papers would be brought forward against us, and that too with great justice, but so far from anything of the kind, that we bid defiance to the world, to produce any deed, or sale, or gift, or lease, of any of the lands in question or any part of them, from us, to either the king of France or Britain, or to either of the United States, or to any individual, excepting those we have adopted into our nation, and who resides with us.*

> *Brothers:*
> *You produce to us a copy of a deed from several Mohawks, for eight hundred thousand acres of land, which these Mohawks had as good a right to sell, as they have to come and dispose of the city of New York, not withstanding this, you at a treaty of last fall, pointed these people out to us, to be too just a people, you thought to do this kind of thing; but what makes them just in your eyes, we expect is because they stole from us, and sold to you. This is what makes them a just people.*[8]

Speeches continued back and forth. The state still refuted that the Indians had any claim, insisting the deal was valid. Gray, Cook, Good Stream and Williams were persistent, however, and the state finally conceded to some of their terms.

The treaty with the Seven Nations of Canada relinquishing their title to the lands in New York State was signed on May 31, 1796.[9] The treaty was signed by Good Stream, Colonel Louis Cook and William Gray, deputies authorized to represent the Seven Nations of Canada; Abraham Ogden, commissioner for the United States; Egbert Benson, Richard Varick and James Watson, agents for New York State; and William Constable and

Daniel M'Cormick, purchasers under Alexander Macomb. The result was the reservation of six miles square—two areas of one mile square around the mills at Salmon River and Grass River and the meadows along the Grass River—creating the St. Regis reservation in northern New York.[10]

In 1797, another treaty was recorded on a federal level by Brant and Deserontyon. This 1797 treaty states "Relinquishment to New York, by the Mohawk Nation of Indians" to all lands within the state.[11] It was entered into by only two men—Brant and Deserontyon—for their own monetary gain. The treaty of 1797 is dated March 29 and was done in Albany.[12] It was signed by Isaac Smith for the United States and bears the marks of Brant and Deserontyon. Brant and Deserontyon were not the deputies appointed by their people. Gray, Good Stream, Williams and Cook were the deputies appointed by the St. Regis only a year earlier.

This 1797 treaty also bears the mark of Cornplanter. His mark on any treaty was considered gold on the part of the United States. It didn't matter that Cornplanter was Seneca. The Indian nation was to receive $1,000, and Brant and Deserontyon were to receive $600 for expenses payable by the State of New York for their part in the land transaction. The Brant and Deserontyon payout was quite a hefty sum considering the entire nation was only to receive $1,000. By today's standards, such a comparative sum would be considered a bribe. Isaac Smith was there to represent the United States; Abraham Ten Broeck, Egbert Benson and Ezra L'Hommedieu were agents for the State of New York.[13] Massachusetts did not need to be present in this case because it did not involve land in Western New York, being land west of Sodus Bay.

At the same time as this was going on, Cornplanter was also being consulted about the Indian land in Western New York and would eventually sign that treaty at Big Tree on September 15, 1797. (There will be more on the Canandaigua Treaty and the Big Tree Treaty in later chapters.)

As surveyed in 1799, the original boundaries of St. Regis proper were: seven and a half miles long on the north boundary; eleven miles, fifteen chains and sixty links on the south boundary; three miles, ten chains and three links on the east boundary; and two miles and forty-one chains on the west boundary, from the state line to the St. Lawrence River. The two parcels of one mile square and the meadows along the Grass River were mentioned separately in case they did not fall within the bounds mentioned previously.

It is apparent that the land was sold in 1797 without the knowledge of the Mohawk people, as was required by the United States president. As a

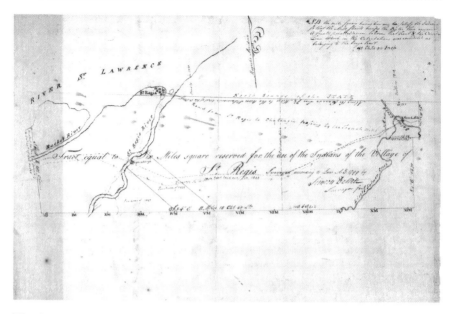

The six-square-mile tract reserved for the St. Regis Indians. Surveyed in 1799 by Simeon De Witt, surveyor general. *New York State Archives.*

people, it would be foolish for them to give away rights to every inch of land in New York for only $1,000.[14]

Now let's look at one of the land claim cases on the subject, *Canadian St. Regis Band of Mohawk Indians v. New York et al.*[15] There are, of course, many issues at hand in a land claim case. What you will find here are excerpts that concern title to the land. It discusses the defense's (New York State) contention, in part, that the St. Regis abandoned the land claim area as well as the state's defense of "state title." The treaty of 1796 is discussed in this case, and the Alexander Macomb Purchase is referred to as a contract, but throughout this case, as well as the previous land claims, there is no mention of deeds recorded by either party and no citations of the book or page on which they appear.

The plaintiffs (the Canadian St. Regis), according to the judge's interpretation of the case, asserted the following:

> *Focusing on the use of the word "reserved," the Tribes maintain that under the plain language of that Treaty, they received recognized or reserved title. Then, although unexpressed, evidently the Tribes are taking the position that because nothing in this record shows that Congress divested the Tribes of their title obtained under that 1796 Treaty, abandonment is not a bar to the Tribes' claims thereunder.*

The judge interpreted the defendant's case (defendants in part the State of New York) as:

> Defendants interpret the 1796 Treaty differently than do the Tribes. As defendants read it, the 1796 Treaty did not confer recognized or reserved title upon the Tribes because it did not "reflect any firm intention to grant [them] permanent rights[,]" such as by using the words "reservation" or "property[.]" Def. Memo. at 30 and 32 (internal quotation marks and citation omitted.) Instead, construing the Treaty more narrowly, the defendants interpret it as "merely maintain[ing] the status quo" in terms of the Macomb purchase mentioned in part of the 1796 Treaty.

As to the defendant's claim to "state title," the judge said:

> Any interest which the Tribes had in the land which was the subject of the 1796 Treaty was "lawfully extinguished" by that Treaty, thus granting the State "full title to such lands." St. An. (82-CV-783) at 14, ¶ 27; St. An.(89-CV-829) at 12, ¶ 30. Any interest which the Tribes may have acquired under that Treaty, the State alleges, "was a right of use only[.]" The court noted, "According to the defendants, that lack of aboriginal title is due to a contract between the State and a private party, Alexander Macomb, to which the Tribes were merely third-party beneficiaries[.]" Id. The court observes that nowhere in the defendants' so-called "State Title" affirmative defenses is there any mention of this alleged contract.

Although the word "title" is being used quite freely, deeds, which are the documents that prove title, are not mentioned. The Macomb Purchase deed clearly reserves land to the St. Regis Indians. Since the state did not mention the "contract" with Macomb in defense of its claim of state title, we will mention it on behalf of the plaintiff's claim of "Indian title." I contend that the state did intend to grant the St. Regis permanent rights, that they were not merely third-party beneficiaries and that the Macomb Purchase was more than a contract—it was a deed that affirmed and expressed the aboriginal title of the St. Regis Indians. Treaties aside, the recorded Macomb deed reserves the land for the St. Regis. From this land claim case and the treaty of 1796, the land in question is described as follows:

First that Treaty provides:

> *That the tract equal to six miles square, reserved in the sale made by the commissioners of the land-office of the said state, to Alexander Macomb, to be applied to the use of the Indians of the village of St. Regis, shall still remain so reserved.*

> *Co. (89-CV-829), Attachment B thereto (1796 Treaty) (emphasis added.) The 1796 Treaty further provides:*

> *That there shall be reserved, to be applied to the use of the Indians of the said village of St. Regis, in like manner as the said tract is to remain reserved, a tract of one mile square, at each of the said mills, and the meadows on both sides of the said Grass river from the said mill thereon, to its confluence with the river St. Lawrence.*

In the introduction, I discussed in depth that treaties should be looked at as agreements to terms and that only documents such as patents, indentures and deeds convey land. It is the accepted means proving legal ownership, and it has always been that way. These deeds also have to be recorded in the county where the property in question geographically falls. Otherwise, for example, Mr. Smith could sell his one parcel to Mr. Jones and Mr. Brown at the same time. The only public proof as to which man really owns it is the deed filed in the clerk's office. If there was no recorded deed to prove ownership on the sale to Mr. Jones, Mr. Brown could easily assert himself as the owner as well. Recording deeds prevents this from happening. If a dispute arises as to clear title to land, one only needs to check the county clerk's records.

The history of a parcel of property is compiled by going through the county clerk's records and creating an "abstract of title." It is like the genealogy of the land going back to the beginning. To think deeds were not recorded for Indian land in New York is a fallacy. It is still land, and the ownership of such needs to be recorded to have an accurate history of any parcel and to prove a parcel is legally conveyed. Deeds were recorded two hundred years ago just as they are today. This rule has to apply to all in order to establish a chain of title from one person to another. It is foolish to assume today that they did not convey Indian land in the same manner. In fact, settlers often bought parcels, only to later discover they did not have clear title. Land claims of any kind, including disputes between two private parties, arise when the rules and laws of land conveyance are not followed.

Sometimes one deed serves as the deed for two separate parcels. For example, Mr. Smith has a farm of five hundred acres he wishes to sell. On it is his family's burial ground. He does not want that disturbed or to

ever change title from the heirs of his family. When he conveys his land by deed to Mr. Jones, he gives the dimensions and then something to the effect of, "being five hundred acres of land excepting fifty square rods of land reserved as a burial ground." He then goes on to explain the dimensions and the terms of the cemetery so reserved. This one deed now serves as two. It serves as the deed to the land sold to Mr. Jones, and it serves as the deed to the Smiths' cemetery. There are many deeds such as this throughout the counties of New York. You can flip open any deed book in any county clerk's office and find several deeds that use the phrase "excepting and reserving." Sometimes it is used to reserve water rights to a well, a shared laneway or acreage of trees. The reasons are endless. It is often used to avoid rewriting and surveying the new land measurements. The Macomb deed is one such deed, as it serves as the deed to Alexander Macomb and the deed to the St. Regis Indians. Reservations, as previously stated, are called "reservations" because the land is excepted out of a parcel and "reserved" to them.

In order to provide a total picture of the land conveyances surrounding the St. Regis reserve, I did a title search beginning with the 1796 treaty. Several counties need to be checked because counties in New York used to be much larger. As new counties were created, the county in which deeds were recorded sometimes changed, depending on where the property was located. When a new county was formed out of another, any important deeds from the county it was taken from were copied (certified) and placed on record in the new county. This was the only way to guarantee that land title for a piece of property could be traced back to the beginning if necessary. In the case of the St. Regis reserve, Clinton, St. Lawrence and Franklin Counties needed to be searched from the date of the treaty in 1796. To be sure not to miss anything, I began my title search in 1788. Indexes for deeds and other records are alphabetical. Because every clerk indexed differently, it was important to use various combinations of words so as not to overlook anything. For example, to do a search on the St. Regis reserve, search terms like "St. Regis," "Saint Regis," "Indian," "Mohawk," "State of New York" and "New York State," as well as the names of the parties involved, were used to search the indexes. Considering all the alleged land sales, there were very few deeds found.

The deed from the State of New York to Alexander Macomb (1798) is a long deed and discusses the original terms.[16] At the point of the actual Macomb purchase, however, there was only estimation of how large each tract was. The deed explains that Simeon De Witt, the surveyor general for the State of New York, was contracted on June 22, 1791, to survey the land, and the exact sizes were smaller than originally thought. The whole

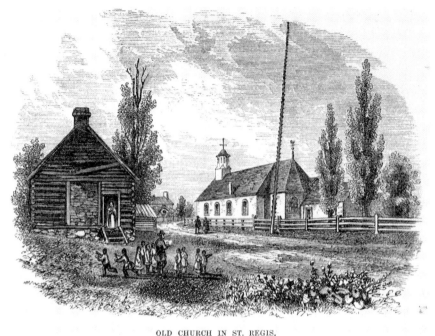

OLD CHURCH IN ST. REGIS.

St. Regis Catholic Mission. *From* Indian History for Young Folks, *by Francis S. Drake.*

agreement and how it is resolved and the change in the terms and land sizes is explained. Part was conveyed to William Constable and Daniel McCormick. Thus, this serves as a deed for their parcels as well. The Macomb deed is cited in other deeds that were created when Constable and McCormick sold off parcels to settlers. This deed has to be cited to show how they received the land and to prove clear title to the land. Noting the conveyance from one person to the next creates the chain, hence the term "chain of title." If the document is a valid deed for Macomb, Constable and McCormick then it must also be a valid deed for the St. Regis.

The deed names certain chiefs and deputies of the Seven Nations of Canada— Abraham Ogden, commissioner appointed by the United States; Egbert Bason, Richard Varick and James Watson, agents for the State of New York; and William Constable and Daniel McCormick, purchasers under Alexander Macomb. It states:

> *ALL AGREED that the tract equal to six miles square reserved in the sale made by one Commissioner of the Land Office to Alexander McComb to*

be applied to the use of the Indians of the Village of St. Regis shall still remain so reserved, and in and by the said treaty it is further stated and agreed as follows: The said deputies having indicated that the Indians of the village of St. Regis have a mill on the Salmon River and another on Grass River and that the meadows on Grass River are necessary to them for hay in order therefore to secure to the Indians of said village the use of said mills and meadows, in case they should hereafter appear not to be included in the above tract, so to remain reserved. It is therefore also agreed and concluded between the Deputies, the said Agents and the said William Constable and Daniel McCormick for themselves and their associates, purchasers under the said Alexander McComb of the adjacent lands, that there shall be reserved to be applied to the use of the Indians of the said village of St. Regis in like manner as the said tract is to remain reserved a

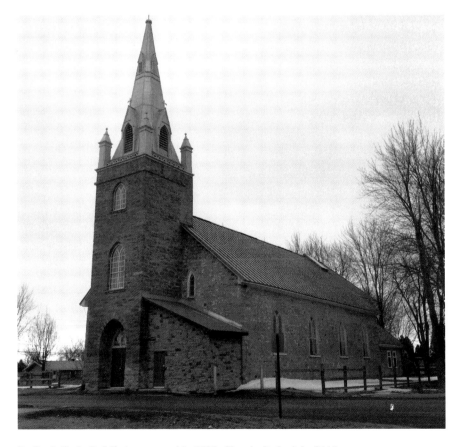

St. Regis Catholic Mission, erected in 1795. *Photo by C. Amrhein, 2015.*

*tract of a mile square at each of the said mills and the meadows on both
sides of the said Grass River from the said mill to its confluence with the
River St. Lawrence as in and by the said treaty of record in one Secretary's
Office will appear. And whereas Daniel McCormick by his memorial
presented to one Commissioner of the Land Office and to which Alexander
McComb and William Constable have signified their assent in writing to
the paper on Letters Patent for the said tracts number one and two.*[17]

It also directed the lands of the St. Regis to be surveyed by the surveyor
general of New York. This conveyance was approved by the commissioner
of the land office, passed through the secretary's office and was signed by
Governor John Jay of New York on August 17, 1798.[18]

They all signed it and agreed to it. The St. Regis were still standing on
their aboriginal land since time immemorial. It was reserved out of the
patent to remain theirs, it was still theirs when this patent was recorded,
therefore the status of the St. Regis land never changed, only the land
around it did. This recorded document shows title to the Macomb purchase,
Daniel McCormick, William Constable *and* the St. Regis Indians. Of course,
the land reserved to the Indians was for their use, that is the point of an
excepting and reserving clause—to reserve a party's rights to the land. If
the rule applies to one, it applies to all. If the land reserved to the St. Regis
is not valid, then neither is any other person's deed recorded showing land
reserved for whatever reason over the last two hundred plus years.

I ran the grantor (seller) indexes for deeds in Clinton County from 1788
to 1836, long after Franklin and St. Lawrence Counties were split from it.
St. Lawrence County was searched from 1802 (when the county formed) to
1928 for the St. Regis, in a variety of ways, as stated earlier. Deed indexes were
run in Franklin County from 1808 (when it was formed) until the late 1800s.
Miscellaneous records, judgment indexes, foreclosures and a variety of other
records were also checked in these counties with nothing further found. Only
two other documents were found in the county clerk's office. The first was a
deed from the St. Regis Indians to St. Patrick's Roman Catholic Corporation
that was filed in 1896 in Liber 78, page ninety-eight of deeds in Franklin
County. The second was a deed for 144 acres, also in Franklin County, which
turns out not to be surface land at all but land under water.

Although, ultimately, the sale of the alleged 144 acres to New York
State can be legally proved, it also proves the state knew very well that
the St. Regis held the title for the land, and in order for the state to
purchase it, they needed a deed. It also proves the State of New York

knew the only legal way to convey land, even from an Indian tribe, was through a deed.

Despite agreements with New York State via treaties from 1816 to 1845, the 144 acres is the only deed of conveyance to the State of New York. As cited in the 2001 land claim case of the *Canadian St. Regis Band of Mohawk Indians v. New York* under the heading "The Original Reservation Land Claim," only purchase five that is listed was a valid sale; however, the state did not take the land that was set out per the deed's land description. As cited from the 2001 case, the purchase is noted as follows: "5) a December 24, 1824 conveyance to the State of 144 acres of the original reservation, with such conveyance purportedly confirmed by the New York Legislature on April 20, 1825." A deed for this conveyance can be found in Liber 3, page thirty-one of deeds in Franklin County, New York.

Neither side of this land claim case took the time to do a title search and copy the deed to see what it said. Had they done a search, they would have found the deed for the 144 acres. If they had an abstractor or surveyor plot out the measurements of the land description, they would have discovered that the 144 acres was not usable surface land. It is actually 144 acres of land under water and a small piece of shore on either side of the St. Regis River in order to run a ferry. That is all. In the next few chapters, we will take a closer look at the treaties with the St. Regis Indians between 1816 and 1845 and also examine the 144 acres in more detail.

THE TREATIES OF 1816 AND 1818

When looking at historical events, who, what, where, how and when need to be looked at in order to understand why something happened. Treaties are more than documents with signatures and rights lost or gained. If you look closely, they are telling a story. In the case of this group of six treaties, they should be looked at collectively, as their stories intertwine and places and people come to life. Over the next few chapters, we will look not only at the treaties in detail but also at the events surrounding them and the motives of some of the individuals involved.

On April 10, 1813, the State of New York had passed a law that stated in part: "That it shall be unlawful for any person or persons other than Indians, to settle or reside upon any lands belonging to any nation or tribe of Indians within this state, and if any person shall settle or reside upon any such lands, contrary to this act, he or she shall be deemed guilty of a misdemeanor."[19]

The fine for violating this law was up to $500 and six months in jail. This created a major problem for settlers. Much of the contested land in recent land claims had once been land leased to settlers by the St. Regis for mills and other purposes. This law made the settlers extremely nervous, worrying not only about possible arrest but also any effect it would have on improvements they made on the leased land. We can assume the act was designed to do just that and to open the door for the state to insist on the purchase of these areas for the benefit and peace of mind of the settlers.

Both the United States and Great Britain agreed that the Treaty of Peace in 1783, which officially ended the Revolutionary War, did not settle the

border dispute between the United States and Canada. It was one of the elements that led to the War of 1812. The war officially ended in December 1814 through the Treaty of Ghent; however, the treaty was not ratified until February 1815. The new treaty provided that the border would need to be accurately surveyed. Negotiations and preparations for the survey took two years. It did not commence until 1817.

Both nations took a renewed look at the strategic importance of lands held by both the Five Nations of Canada and the Six Nations of New York. Each government took into consideration the allegiance of certain members of each tribe and whom they fought for. In the treaty between the governments that ended the war, both sides conceded the following in article nine of the Treaty of Ghent:

> *After the Ratification of the present Treaty to hostilities with all the Tribes or Nations of Indians with whom they may be at war at the time of such Ratification, and forthwith to restore to such Tribes or Nations respectively all the possessions, rights, and privileges which they may have enjoyed or been entitled to in one thousand eight hundred and eleven previous to such hostilities.*

Henry Goulburn, undersecretary for war and the colonies of Great Britain, wrote a letter dated January 2, 1816.[20] Although it is not indicated who the letter was to, it was in regard to the Five Nations of Canada and the Six Nations of New York. In the letter, he explains he had settled the matters concerning the Five and Six Nations before Lord Bathurst, secretary for war and the colonies, confirming the Haldimand Grant (in Canada) of October 25, 1784. This grant of land extended for six miles on both sides of the Grand River, from its source to Lake Erie. This is the tract of land granted to Joseph Brant and his Indian allies in recognition of their service to the British Crown during the war. With a tract for himself in Canada, he had no trouble signing away all rights to the Indian land in New York State, despite his lack of authority to do so. In the letter, Goulburn states, "There is no difficulty on the part of his Majesties [*sic*] government to admit that the Grant of the Grand River, which was after the peace of 1783, made by the five Nations and their posterity forever is a grant as full and as binding upon the government as any other made in Canada to individual settlers." In other words, it was the Five Nations' land to do with as it wished.

The letter is lengthy in its concern that allotments would be made to United States investors. Goulburn also requested that land be allotted for the "Wyandots, Delawares and the other Indian Nations now living in the

vicinity of Canada" under the same conditions and terms as the grant on Grand River. We now have a view of what Britain's dealings with the Indians were at this point in time. (As with all land allotments to the Indians, this grant would be encroached on and contested in modern times.)

In the United States, New York was taking matters into its own hands, with renewed interest in the lands leased by settlers in the St. Regis reserve. A treaty was arranged to begin the negotiation process. From all appearances of the treaty of 1816, it was held without the presence of the United States government. This treaty was signed on March 15, 1816, in Albany and begins:

> *A treaty made and executed between Daniel D. Tompkins Governor of the State of New York in behalf of the People of the said state of the one part, and Peter Tarbell, Jacob Francis and Thomas Williams for and in behalf of the Nation or tribe of Indians, known and called the "St. Regis Indians" of the second part.*[21]

The first thing that should be noted before going further is that there is no representation from the United States government on behalf of the St. Regis tribe. This was mandatory by several federal acts and laws. Secondly, in regard to the St. Regis representatives, I have not been able to establish the ethnic origin of Jacob Francis, but Tarbell and Williams were half native. This is not intended as a slur to any group of people but as an observation on the reasoning of the United States government. It seems like the United States and land speculators followed a pattern when choosing who to work with and why. Did they think these men would be easily swayed to convince the Indian nation they now were a part of to agree to less-than-beneficial terms? The use of chiefs and interpreters of mixed blood—many raised with white men for the first part of their lives—to help negotiate treaties might very well have been intentional.

Thomas Williams was born in Caughnawaga about 1789 and descended from Reverend John Williams of Deerfield, Massachusetts. The reverend's family was taken captive in 1704. Although they were released, daughter Eunice preferred to remain with the Indians and was adopted. She married a chief and bore three children, one by the name of Mary. Mary is the mother of Thomas Williams. Peter was the son of Lesor Tarbell, one of the two brothers—the other being Loran—who were captured from Groton, Massachusetts. The brothers were taken to Caughnawaga, where they married. They traveled down to St. Regis with their families and settled there. This raises the question about whether they should have been allowed

to conduct a treaty on behalf of the St. Regis Indians, since they could have been predisposed to the culture of their origins, and are their signatures binding because of that fact? There also is no mention of an interpreter present. Because the above men were born or raised as Indians, they may have been able to speak English well enough, but they may not have been able to read or write in English and would have had no idea what they were signing. This is evident, as they signed the treaty with *X*s next to their names written by someone else, indicating that they themselves could not write.

A state law passed in 1816 allowed the state to purchase land from the St. Regis based on whatever the governor considered a reasonable amount, paving the way for a treaty. There were three articles to the treaty of 1816. The first article was to convey the one mile square on Salmon River and five thousand acres off the east end of the St. Regis reserve (Fort Covington, then called French Mills and B in the present land claim area). Article two states that the governor agreed to pay an annuity of $1,300 "forever hereafter" on the first Tuesday of August next and every year thereafter. Article three notes that the St. Regis would authorize three of its chiefs or principal men to receive the annuity. "And the receipt of the said chiefs or principal men, so deputed, shall be considered a full and satisfactory discharge of the people of the State of New York, from the annuity which may be so received." Article three is rather odd. Does it mean they are discharged for the year, or that once the St. Regis actually take the money in August 1817, New York would be discharged of its obligation, period? That is an unknown without access to records of payments.

By an act of the state legislature in March 1802, the St. Regis were "allowed" to appoint trustees to act on behalf of the tribe. At the time, they had appointed William Gray, Louis Cook and Loran Tarbell. William Gray had been taken prisoner during the War of 1812 and taken to Quebec, where he died. Louis Cook had died near Buffalo. After their deaths, Loran Tarbell then took on the counsel of Peter Tarbell and Jacob Francis.

Now let's look at the signatures on this treaty. Peter Tarbell, Jacob Francis and Thomas Williams signed with *X*s by their names. If they were present, this indicates they may not have understood what they were signing. They most likely would have thought it was another lease, especially without an interpreter present. If they were not there, anyone can make an *X* as long as the witnesses and notary to the signatures goes along with it. We may never know what the case was.

Daniel D. Tompkins, then governor of New York, signed the document himself. It just so happens he would serve as vice president of the United

States from March 4, 1817, to March 3, 1825. He was in the midst of an election year during this treaty. The treaty was witnessed by Michael Hogan, who we will discuss in regard to the 144 acres in Hogansburg and see what he had to gain; John Taylor, who was a Republican member of Congress from New York; and New York state surveyor general Simeon De Witt, who ended up with a piece of land at some point near Massena, most likely after a law was passed in 1821 that gave him permission to lease land there to whomever he felt were fit and proper.[22]

Smith Thompson, chief justice of the Supreme Court, was the notary who witnessed the signature of Michael Hogan. Hogan swore that he saw Daniel D. Tompkins, Peter Tarbell, Jacob Francis and Thomas Williams execute the treaty and that "John Taylor, Simeon De Witt and the deponent [Michael Hogan], subscribed their names as witnesses to the execution of said treaty." For this document to be valid, the notary himself would have needed to witness and notarize the signatures or marks of Tarbell, Francis and Williams, which he did not do. He only witnessed Michael Hogan's signature and took Hogan's word that he saw the St. Regis trustees sign it. The notary did not personally see the St. Regis men sign. That was as illegal then for a notary to do as it is today. Since Chief Justice Thompson, the notary, did not personally witness the signatures of Tarbell, Francis and Williams, it puts the validity of the treaty in question.

It was not unusual for the St. Regis to lease their land, and if they did sign the treaty of 1816, it is probable that they thought it was another lease. Without an interpreter, it is impossible to know what they may have been told. Michael Hogan, Daniel D. Tompkins, John Taylor and Simeon De Witt were biased, and all had something personally to gain from this transaction. They had free rein to do what they wanted because there was no one there to challenge them on the Indians' behalf. The St. Regis had no representation whatsoever, no one to explain to them what was really happening, and they were severely taken advantage of. There is no way to view this type of transaction other than as fraud. There also is no deed filed in St. Lawrence or Franklin Counties showing the transfer of land that corresponds to this treaty.

Thomas Williams, one of the signers of that treaty, had a son named Eleazer (sometimes spelled Eleazar) born in about 1787. Raised among the Mohawks, Eleazer was sent to what is now known as Dartmouth College and later became a minister. (The particulars of his life will be gone into in more depth in another chapter.) Eleazer Williams spent most of his life among the Oneidas, first in New York and later in Green Bay. In the historical

accounts of New York, he is spoken of highly. However, in Wisconsin, where he spent the majority of his life and where more records on Eleazer Williams exists, he is documented as one of the oddest characters in the state's history. Williams's other life was filled with illusions of grandeur, self-adoration and schemes to create an "Indian Empire," with himself as its leader. His influence on the negotiations in the later treaties of 1824 and 1838 had a direct impact on the loss of Indian land and provides the evidence of his self-interest.

During the year of 1816, Eleazer Williams went to live among the Oneidas. His success in spreading the gospel was noticed in the religious community. Within a short time, he was in Albany, along with an Oneida chief and an interpreter, for a cession of the Oneida land in order to build a Protestant Episcopal church. The church was completed within a year. Williams had higher aspirations than this group of Oneidas. By 1818, he was cautiously broaching the subject that the "Christian-thinking Indians" should move west. He had created a grand plan to present to the chiefs of the Oneidas. Although it piqued the interest of the younger men, the older, wiser chiefs doubted his plan, and he began to lose favor with them as quickly as he had gained it. With the support of the younger men, Williams approached the rest of the Six Nations and, finally, the United States War Department, which was already thinking of moving the Indians of New York to the west, the idea having already been brought to them by the Ogden Land Company. Eleazer Williams was only too happy to oblige.

On February 16, 1818, Loran Tarbell, on behalf of the chiefs of the St. Regis, petitioned the legislature to have Peter and Jacob made permanent trustees to replace the two who had died. William L. Gray (William Gray Sr.'s son) served as the interpreter for composing the letter. An act was passed on April 13, 1818, accepting the request.

Another treaty was held with the St. Regis in 1818 because the treaty of 1816 did not cover all the territory that had been leased by white settlers. It was conducted in Albany on February 20, 1818. This treaty was between Governor DeWitt Clinton and Loran Tarbell, Peter Tarbell, Jacob Francis and Thomas Williams on behalf of the St. Regis. William Henry Gray served as the interpreter. The treaty concerned two thousand acres of land that abutted the west side of the five thousand acres that was supposedly ceded in 1816. It was to include a road running north–south through the reservation and another east–west through the reservation, the roads being four rods, or sixty-six feet, wide. The roads were to be laid out by Michael Hogan and Loran Tarbell. An annuity of $200 was to be paid forever to the

St. Regis. The treaty going into effect was based on the condition that any arrears on leases owed to the St. Regis had to be paid.[23]

Again, we have the same sort of signatory section. The notary, Archibald Campbell, did not witness the signatures of the Tarbells, Francis or Williams himself. He only notarized the signature of Michael Hogan swearing to the fact that the men from the St. Regis had signed the document.

The St. Regis chiefs wrote a letter to the New York state legislature on January 20, 1823. In the letter, they complained that the treaty was based on the condition that the arrears of leases were to be paid. Since five years later the arrears still had not been paid, as stipulated as a condition to make the treaty binding, it is possible that the 1818 treaty was not validated. If this is the case, it brings into question the validity of the conveyance of two thousand acres and the two road easements through St. Regis territory. There was no deed found from the St. Regis to the State of New York filed in St. Lawrence or Franklin Counties for the conveyance or for any easements for the roads.

THE TREATIES OF 1824

In 1820, with the approval of the War Department, Eleazer Williams took a delegation of Christian-thinking Oneidas west but only made it as far as Detroit upon learning that part of the land had been ceded to the United States. In 1821, he set out again for Green Bay with a group of Oneidas, Onondagas, Tuscaroras, Senecas and Stockbridges; there were fourteen men, including himself.

The *Detroit Gazette* reported that they arrived on the steamboat *Walk-in-the-Water* on July 12, 1821. It was later reported they left by the same ship on July 31 and arrived in Green Bay on August 5. Per the treaty dated August 18, 1821, Eleazer Williams served as a deputy "authorized and empowered to represent the St. Regis Indians of the State of New York" in securing the land in Green Bay that was ceded by the Menominee and Winnebago. His authorization was only through the U.S. government. As we know from the 1818 petition of Loren Tarbell, Eleazer Williams was not a deputy appointed by the St. Regis. In other words, he had no authority from the St. Regis to sign anything on their behalf.

Upon his return to New York, Williams met with an unfavorable response from the Oneida chiefs. A letter from the Oneida chiefs was written to President James Monroe complaining that Williams was not Oneida but St. Regis and didn't represent them. Despite some protest that split the tribe on the issue, another delegation arrived in Green Bay in 1822 and 1823. The Tuscaroras, Senecas and Onondagas, having become more strongly against the idea, were not among them. Williams was beginning to fall out of favor in New York, except with the St. Regis.

Eleazer Williams traveled between Green Bay and New York often—with multiple motives—and was one of the signatories on the 1824 treaties with the St. Regis.

On January 20, 1823, the St. Regis petitioned the state legislature, complaining that the arrears had not been paid and that the state had already sold land to individual settlers.[24] Acts were passed by New York State in 1824 to pay a sum not to exceed $735.07 to the St. Regis for arrears in leases for land under the treaties of 1816 and 1818. The money was to be given to Asa Hascall, district attorney of Franklin County, to disperse to the St. Regis. It is unknown if this was ever done without viewing records of receipts or accounting ledgers if they even exist. This does seem a rather small amount of money for seven thousand acres of land and over eight years of rent in arrears on leases.

At a general council held on March 8, 1824, the St. Regis decided to appoint new trustees. The tribe granted them power of attorney to handle the upcoming treaty and any thereafter. The new appointments were Thomas Williams, Mitchel (sometimes spelled "Michel" or "Mitchell") Cook, Lewis Doublehouse and Peter Tarbell. Inserted into the line of names is John Williams, but there is no indication as to who he was or how he was involved. The transfer of power of attorney was witnessed by John Hadcocks and Eleazer Williams. The chiefs' signatures weren't notarized at the time of signing. The only signatures that were notarized were that of John Hadcocks and Eleazer Williams, who said they saw the chiefs sign, and this was not done until March 16, the day of the treaty (see appendix).[25]

On March 9, the St. Regis drafted a petition to the New York state legislature requesting its approval of the new appointments for the tribe, stating their "old chiefs who were appointed as Trustees are all Dead Except one who is old."[26]

The treaty was held in Albany on March 16 between Governor Joseph C. Yates and the St. Regis to convey the one mile square of land in Massena and the mill on the Grass River.[27] The treaties we now encounter with the state are different from the earlier ones; they became like double-edged swords, with two different meanings.

As I have previously stated, when it comes to the actual land, I view a treaty as an agreement to purchase land, similar to a purchase offer or an option to buy. Only a deed conveys land. If no deed is filed, then the transaction should be considered incomplete. There are no deeds for the treaties of 1816 and 1818. This could be because the arrears on the leases were never paid. In view of the trouble New York State had with the treaty of 1818, it being

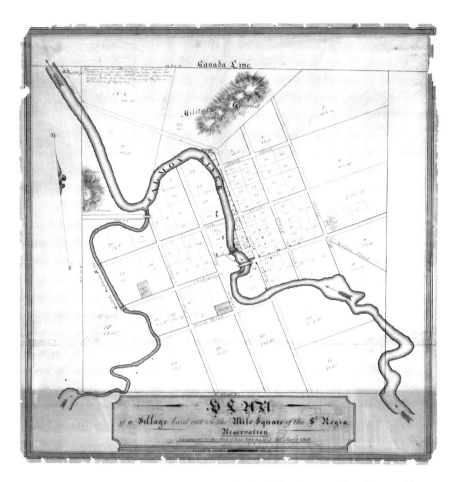

The "mile square" at Massena village, laid out in the St. Regis reservation. Surveyed in 1820 by Simeon DeWitt, surveyor general. *New York State Archives.*

binding only on the condition that the arrears of rent owned to the St. Regis were paid, the state took a new approach to avoid the problem.

The treaty of March 16, 1824, begins "at a *treaty* held in the City of Albany," so there is no doubt that it is a treaty. It was signed by Governor Joseph C. Yates. The marks of Thomas Williams, Mitchel Cook, Lewis Doublehouse and Peter Tarbell were also witnessed on March 16 in the presence of John Hadcocks and Eleazer Williams. (John Hadcocks already had a reputation for unfair dealings as far as the Stockbridge Indians land was concerned. He had reserved two patents—one before the treaty of February 3, 1823, with the Stockbridges—and one written into the treaty.

The mess was brought before the committee on Indian affairs.[28]) With no representative from the United States, no honest interpreter present and only Eleazer Williams, Hadcocks and Governor Yates to rely on, one can't assume that the dealings with the men from St. Regis were fair.

It is probable that the St. Regis were relying on Williams to interpret, unaware of his personal interests, and explain to them what they were signing. By their marks of an *X* next to their names, it is clear they could not read or write English. As we go along in history, it will be proven that Eleazer had his own agenda—and it wasn't spiritual. A certified copy of the original treaty is recorded in volume 41 of the legislative assembly papers from April 1, 1824.[29]

This treaty is rerecorded in the volumes of Indian treaties from October 20, 1824.[30] It is identical to the one recorded in April in the volumes of legislative assembly papers (aside from random capitalization differences) except that a lengthy notary section was added to the end of it declaring the treaty a deed (see appendix). This added section recites, "On the seventeenth day of March in the year one thousand eight hundred and twenty four, came before me Joseph C. Yates Governor of the State of New York to me known and also Eleazer Williams a subscribing witness to the execution of the within *deed* to me also known." Before we go further, the words "came before me Joseph C. Yates…and also Eleazer Williams" mean the notary is only bearing witness to the signatures of Yates and Williams. The St. Regis trustees, however, did not sign a deed. Notice that this section is also dated a day later; the St. Regis trustees were most likely not there, if indeed the signing happened the next day and not in October. The state is calling the treaty a deed by the section added to the end *after* the St. Regis trustees' signatures. In reading the opening words of the document, the trustees clearly signed a treaty, an option to sell, which cannot be confirmed as a legal conveyance without the execution of a deed. I believe the men on behalf of the state knew this and added a paragraph at the end declaring the treaty a deed, which appeared when the document was recorded six months later.

It goes on to say, "And thereupon the said Joseph C. Yates duly acknowledged to have executed the within deed for the uses and purposes therein mentioned and the said Eleazer Williams on his oath says that *he* saw Thomas Williams, Michel Cook, Louis Doublehouse and Peter Tarbell who are well known to the witness execute the within *deed*." The notary only acknowledged the governor's and Eleazer Williams's statements and signatures that all this—that the treaty was a deed—was true. This would be easy to do in the absence of the St. Regis trustees.

As stated before, this is not acceptable or legal, then or now. The notary did not witness the signatures (or marks) of Williams, Cook, Doublehouse or Tarbell himself. In order for the attached claim of a deed to be legal, the trustees would have had to sign it again in the same added notary section. This, of course, was not the case. In other words, the governor and Eleazer Williams proclaimed the treaty to be a deed in a paragraph after the St. Regis signatures and before the notary signature without the St. Regis trustees being present. The addition is not on the original copy that was recorded in April. It does solve the state's problem of trying to get a deed away from the St. Regis after the signing of a treaty when back lease rents were still owed to the tribe.

Two months later, on May 31, 1824—and most likely after the chiefs found out what happened—the St. Regis forwarded a letter to the New York state legislature stating that there were some changes in the trustees and making very clear who represented them by adding, "We will not henceforth encourage any other individual to be chiefs, or trustees, except Thomas Williams, Michel Cook, Lewis Doublehouse, Peter Tarbell, and Charles Cook; and we do hereby fully authorize, and empower them to transact for, and on behalf of our said tribe of American St. Regis Indians, all manner of business which they may deem for the general good." It should be noted that there is no mention of Eleazer Williams being one of their representatives. In fact, this letter makes clear who can legally speak on their behalf and sign documents. The rest of the treaties from 1824 continue with the same bogus signature section (with the exception of the one real conveyance to the state of the 144 acres of land under water.)

The treaty of June 12, 1824, was to convey one thousand acres of the reservation.[31] Although the beginning words state it was a treaty and the aforementioned St. Regis trustees signed it as such, there was no United States representative. The treaty was witnessed by Isaac Denniston (who also witnessed some of the Oneidas' treaties), and Eleazer Williams was the interpreter. The treaty has the same acknowledgement paragraph at the end with Governor Yates and Eleazer Williams declaring the treaty a deed.

On December 14, 1824, we find the only conveyance to the State of New York that followed the proper procedure for conveying land.[32] It is from the St. Regis trustees to the State of New York conveying the 144 acres the St. Regis had leased to Michael Hogan to operate a ferry. It is not only filed in the New York State volumes of Indian treaties, held at the state archives, but also is recorded in the Franklin County clerk's office. It is a standard deed—the exception that proves the rule, as they say—that the State of New York knew full well the legal way to convey Indian land.

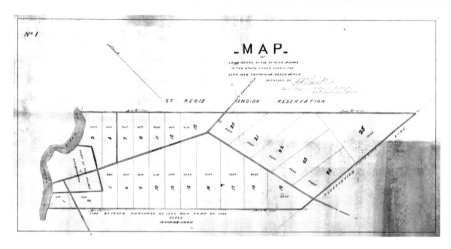

Map of land ceded by the St. Regis Indians to the State of New York in 1824, containing 1023 34/100 acres. *DEC Division of Lands and Forests, 1885. New York State Archives.*

The deed for the 144 acres of land under water has a legal notary section, the notary saying that it was notarized on January 3, 1825, and that Thomas Williams, Mitchel Cook, Lewis Doublehouse, Peter Tarbell and Charles Cook *personally* appeared before *him*, the notary, and executed the deed. They were questioned, through their interpreter William L. Gray, to make sure they understood what they were signing. This was legally done, and is a sharp contrast to the previous treaties of 1824. You will also notice that William L. Gray is the interpreter and not Eleazer Williams.

If the conveyances of 1816, 1818 and the previous one from 1824 were legal, there would have been separate deeds, and the documents would have been recorded in the county clerk's office with the correct signature section just like the deed from December 1824. All of this is further proof that the only legal conveyance from the St. Regis to the State of New York was the 144 acres. However, this transaction has its own trail of deceit. What is actually water and land under water, along with a bit of shore in order to dock boats and operate the ferry, will be taken by the state as a sizable chunk of land, what is called the village of Hogansburg.

4
THE 144 ACRES OF MOSTLY WATER

On October 20, 1817, the St. Regis leased to Michael Hogan one hundred acres for ten years, "being on both sides of the St. Regis River within their reservation lands."[33] This document clearly states it is only a lease and in no way conveys ownership. The lease is from the Tribe of St. Regis Indians to Michael Hogan. He was to pay $305 a year every October 20 and "also for the said ferry which the said Hogan promises to establish in conformity to the New York Act of March 1806 on or near said land after the frost of the ensuing winter breaks up."[34]

The legal description detailing the measurements is written in the lease. Although some of the marker points may be difficult to find, it might be possible to have a surveyor resurvey it today. It begins at a white oak tree scored and marked near the west chimney of the deceased John Gray's house. The lease is signed by Loran Tarbell, the survivor of the trustees named in said act (meaning the Act of 1802 naming the St. Regis[35] trustees), along with the subscribing chiefs who were acknowledged by their marks as Loran Tarbell, Peter Tarbell, Jacob Francis and Joseph Tarbell. It was also signed by Michael Hogan.

On the following page of the document, dated October 23, 1817, the tribe agrees to "let to the within Michael Hogan the remaining forty-four acres of the farm formerly belonging to John Gray our brother Chief deceased on the same conditions as are contained in the within lease." The interpreter was William L. Gray. The original lease of October 20, 1817, was not filed until after the December 14, 1824 treaty. The lease

needed to be recorded in the clerk's office in order for the state to prove clear title to the land. It was recorded on August 13, 1825, in Liber 3 of deeds, pages 24 to 25, in the Franklin County clerk's office.

Notice the words in bold type in Table 1. It describes the water and land under the water with a minimal amount of shoreline. The document on the forty-four acres was attached after, as it is recorded in with the 1817 lease. Hogan then conveys all the lease rights to himself and John Glendenning Jr. in the following recorded document, which begins on the bottom of page 26 in Liber 3 of deeds in Franklin County.

If the state did not believe that the St. Regis held title to the land, there would have been no reason to go to them to purchase land in the traditional sense—but it did. All treaties aside, there is only one deed recorded from the St. Regis to the State of New York during this contested time frame. The state allowed the transaction based on the "Act passed the 28th day of May, 1802 entitled an Act for the Benefit of the St. Regis Indians." As it turns out, it really wasn't land at all. The reason I know this is because the other part of the abstractor's job is to be able to plot out a parcel by the measurements given in the lease or deed description. One of the major problems with the land claims concerning the disputed 144 acres is that no one ever pulled the actual deed to see what it said.

On December 14, 1824, the St. Regis Indians released the lease and executed a quit claim deed (a bit different than a warranty deed, in which the person guarantees clear title, a quit claim deed is exactly what it says—the person is quitting his or her claim to the property and does not warrant anything about the title being clear) for the 144 acres to the State of New York for one dollar.[36] It bears the marks of Thomas Williams, Mitchel Cook, Lewis Doublehouse, Peter Tarbell and Charles Cook; William L. Gray was the interpreter. It was the original lease dated October 20, 1817. It was recorded in Franklin County, also on August 13, 1825. On September 13, 1825, William Hogan (and wife) and John Glendenning Jr. conveyed their rights to the lease to the State of New York and recorded it in the Franklin County clerk's office.[37] Table 2 explains the lease rights for 100 acres and also the legal description for the 44-acre parcel of land adjacent to the 100 acres that the Hogans and Glendenning conveyed to the State of New York.

Let's take a closer look at this original lease to Michael Hogan for the 144 acres. The legal description of the 144 acres per the measurements in the lease is the same description in the deed from the Hogans and Glendenning to New York State, as well as the deed from the St. Regis to the state.

St. Regis River. *Photo by C. Amrhein, 2015.*

To see precisely the land that was at issue, I converted the measurements of rods, links and chains in the original leases and compared it to the deeds to plot it out. Needless to say, I was surprised by the discovery. You can see in the rendering that part of the 144 acres was mostly water and only enough land to conduct the ferry across the St. Regis River.

The leases and deeds clearly state:

> *To contain one hundred acres lying and being on both sides of the St. Regis River within their reservation lands in the county of the Franklin & State of New York including the whole of that part of the River St. Regis running through the said one hundred acres which stream of water is measured therein.*

It also includes the terms "across the said river and including the river," and at the end of the legal description, "containing one hundred acres of land and land under water." The wording in the lease states that Jonathan Wallace surveyed it. Since the lease is dated October 20, 1817, it means Wallace surveyed it before Hogan took out the lease. The lease itself is not

recorded until seven years later, when the St. Regis conveyed it to the state. A lot can happen in seven years—and it did. The land around the ferry was encroached upon by settlers creating Hogansburg.

The date of the Hogans' deed to the state was dated September 13, 1825, and recorded on the twenty-first of the same month, two days before the September 23, 1825 treaty to convey one thousand acres in the same area. In February 1825, a survey had been made showing the one thousand acres as well as the area that was "Land leased to M. Hogan." He now has a parcel of considerable size, not just a bit of shoreline to run a ferry.

The survey is part of the collection of the New York State Archives. It is in poor condition and won't reproduce with clarity. A digital image of the original map is online as part of a collection of survey maps that relates to the State of New York.[38] An 1885 survey held in the collection of the New York State Department of Environmental Conservation shows that the land the state surveyor drew out per the treaty of June 1824 belongs to Michael Hogan, now marked as Hogansburg. When comparing the rendering with the deed measurements and the survey by the state, it is obvious that nothing matches up. The survey, done this time by Sam B. Anderson, and prior to the 1825 treaty, is all land and no water. It would seem he surveyed the area encroached upon by the settlers, which in no way follows the land description on the deed itself. The St. Regis were right to feel they had been cheated.

In 1943, the St. Regis first brought this case to court. In the case of the *United States v. Franklin County*,[39] the United States was suing the county on behalf of the St. Regis Indians over a taxing issue for land that was in Hogansburg. Although the complaint was dismissed, it does shed some light on the disputed 144 acres. The history, according to the judge's ruling, is laid out as follows:

> *It is the claim of the plaintiff that the ten parcels of land referred to in the complaint are in fact a part of the tribal lands of the St. Regis Indians, and are, therefore, exempt from taxation.*
>
> *It appears that the Village of Hogansburg has been built within the 144 acre tract; that that tract has been subdivided and sold to different owners, among which subdivisions are the ten parcels of land referred to in the complaint, which for a long period of time have been subject to taxation and taxes so levied have been paid…The record title of the ten parcels of land referred to in the complaint is held by the ten members of the St. Regis*

tribe by reason of conveyances based upon the patent issued to Hogan and Glendenning. They do not hold the lands either by allotment or under any authority of the St. Regis tribe.

The case was dismissed, in part, due to "the lack of evidence to show the invalidity of the leases of 1817 and the conveyance of 1824." There appears to be some confusion in this claim from 1943. The St. Regis Indians were sure of what they owned and have long contended that some of these parcels were encroachments on their territory. The judge in the case is assuming that the 144 acres was acres of "land" within the village and based his ruling on that assumption. Nobody ever plotted out the 144 acres to see exactly what it was and where it fell geographically in the village.

Although ultimately the sale of the 144 acres of mostly water followed the proper procedure for land conveyance, the land known now as "Hogansburg" is not what the St. Regis conveyed to the State of New York. This conveyance also proves that the state knew very well that the St. Regis held the title for the land around the ferry, and in order for the state to purchase the land, it needed a deed. It also proves the State of New York knew the only legal way to convey land, even from an Indian tribe, was through a deed. This is why it calls all the distance measurements and degrees the "legal description" of the land discussed in the deed. Despite agreements with New York State via treaties from 1816 to 1845, the ferry deed of 1824 is the only deed showing a conveyance to the state. Although it was only to conduct a ferry, in the end, the state managed to swindle the St. Regis out of the land. (As with surveyor Joseph Ellicott cheating the Senecas out of Buffalo by surveying around them, this is another case of a surveyor taking liberties.) A surveyor would have been able to read a deed description and know that his drawing was incorrect.

As cited in the case of *Canadian St. Regis Band of Mohawk Indians v. N.Y.*,[40] in the claim from 2001, under the heading "The Original Reservation Land Claim," what is described as purchase 5 is the only valid transfer, paper wise. As cited from the 2001 land claim case, the purchase, "(5) a December 24, 1824 conveyance to the State of 144 acres of the original reservation, with such conveyance purportedly confirmed by the New York Legislature on April 20, 1825," which is meant to be the deed found in Liber 3, page 31, of deeds in Franklin County. The State of New York, in that case, followed the proper procedure of transferring title, but the state believed the property was all land, which it was not.

The St. Regis reserve straddles the border of the United States and Canada, which adds to the confusion. If the St. Regis present a land claim case, they should have something to do with land title and tenure. Remember, the St. Regis did not buy the land described in the treaty of 1796; they retained it in its original form. It was theirs before, and it was theirs after, it never changed hands and never changed its aboriginal status. Because there were no deeds drawn up and signed by the trustees of the St. Regis to go along with the treaties from 1816 to 1845 (other than the conveyance of the ferry) the options to buy the land per the treaties was never completed. It is hard to see how the deal could be considered finalized without a deed of sale.

From an abstractor's point of view, the residents of Hogansburg also have a claim against the State of New York. To the best of my knowledge, the people did not build their homes on stilts in the middle of the St. Regis River waters that most of the 144 acres actually cover. So the acreage that was parceled out by the state to become part of the village of Hogansburg had to come from somewhere. It is apparent that it really was an encroachment, as the St. Regis always claimed. The people who built their homes on this land believed the state conveyed what they owned. The state erroneously guaranteed "clear" title to settlers, in a binding document, for land the State of New York knowingly did not have clear title to. The state acted dishonestly toward the Indians and the settlers. Both sides of the land claim issue have a right to complain. The blame falls on the State of New York for creating the problem and not following the law in regard to land transfers. Unfortunately, at this point in time, there is no simple solution to the problem.

Table I

CORNER 1	Beginning at a white oak tree scored and marked from which the west chimney of John Gray's house bears
Line 1 to 2 N 62° E 510.84 ft	N 62° E 7 chains and 74 links
CORNER 2	(chimney)
Line 2 to 3 S 48° E 379.5 ft	Thence S 48° E 5 chains and 70 links to the west bank of the river (meaning the St. Regis River)
CORNER 3	(west bank of the river)
Line 3 to 4 S 48° E 2267.1 ft	Thence continuing the same course **across the river, and including said river**, 34 chains and 30 links to a stake….
CORNER 4	…stake cornered and marker "H"
Line 4 to 5 N 33° E 1749 ft	Thence N 33° 30 minutes E 26 chains and 50 links to a stake
CORNER 5	…to a stake cornered and marked "H"
Line 5 to 6 N 48° W 627 ft	Thence N 48° W 9 chains and 50 links to the south bank of the river
CORNER 6	(south bank of the river)
Line 6 to 7 N 48° W	Thence continuing the same course **over the surface of the river** about the middle of the river to a pine stump a little to WSW of a white oak tree within the field on the west side of the river and about west of the lower island
CORNER 7	(pine stump)
Line 7 to 1 S 30° W 1749 ft	Thence S 33° 30 minutes W 26 chains and 50 links to the place of beginning containing 100 acres of land **and land under water**…. Per survey made by Jonathan Wallace, surveyor. (The next page of this deed conveys the other 44 acres. For legal description see deed 3/81)

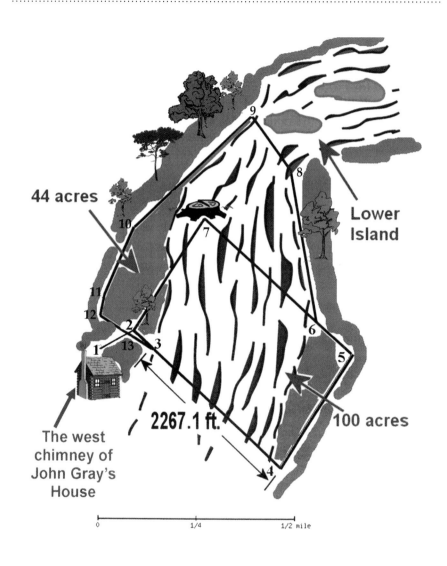

44 acres

Lower Island

The west chimney of John Gray's House

2267.1 ft.

100 acres

0 1/4 1/2 mile

The 144 acres leased by Hogan to run a ferry across the St. Regis River, drawn using the measurements in the lease. New York State erroneously plots this out as land that becomes Hogansburg. *Graphic by C. Amrhein, 2015.*

TABLE II

CORNER 1	Also that certain other and adjacent piece of land beginning at a large black oak tree on the northwest corner of the land of the said St. Regis river, the southeast corner of the second island below the rapids bearing S 13° 30 minutes E and running thence
Line 8 to 9 N 36° W 842.82 ft	N 36° W 12 chains 77 links to an oak sapling cornered
CORNER 2	(oak sapling)
Line 9 to 10 S 47° W 2153.58 ft	Thence S 47° W 32 chains 63 links to a poplar tree cornered
CORNER 3	(poplar tree)
Line 10 to 11 S 24° W 924 ft	Thence S 24° 30 minutes W 14 chains to a stake
CORNER 4	(stake)
Line 11 to 12 S 14° W 297 ft	Thence S 14° W 4 chains 50 links to a stake cornered
CORNER 5	(stake)
Line 12 to 13 S 58° E 475.2	Thence S 58° E 7 chains 20 links to a stake on the west bank of the river
CORNER 6	(west bank of the river)
Line 13 to 3 S 48°E	Thence **down and along the banks of said river** to its intersection with a line running S 48°E from a white oak tree from which the west chimney of John Gray's house bears N 62° E distant 7 chains & 74 links
CORNER 7	(intersects at line)
Line 3 to 2 N 48° W 379.5 ft	Thence N 48° W along said line 5 chains 70 links to said oak tree

Corner 8	(oak tree)
Line 2 to 7 N 33° E 1749 ft	Thence N 33° 30 minutes E 26 chains and 50 links
Corner 9	
Line 7 to 6 S 48° E (2016.3)	Thence S 48° E **to the bank of the river** aforesaid
Corner 10	
Line 6 to 8	Thence down and **along said river bank** to the place of beginning containing about 44 acres of land

THE TREATY OF 1825

They used to be called treaties. Now they are called "compacts" or "memorandums of understanding." Call them whatever you like, a treaty by any other name is still a treaty. Despite the passage of time, nothing about how treaties are done has changed, and nothing in all that time has been learned. All that is needed for a treaty to take place is a few willing players. On the one side, there is the group that wants the land—be it a governmental body or a company such as the Ogden Land Company—and an Indian agent who has always served his own interests, such as Jasper Parrish and Augustus Porter. On the other side, there are a few willing Indians, be they chiefs or not, to go along with the plan. These chosen Indians need the right qualities though; they must be Indians who do not hold their land sacred and are willing to trade it away for a bribe in goods, land of their own or cash. Now, just as then, there are always those who are willing to do anything for money.

Before picking up the story where we left off in the last chapter, a review of the parties involved might be of benefit. As of May 1824, the chiefs and trustees of the St. Regis were Thomas Williams (born at Caughnawaga, descendant of Reverend John Williams, who was captured in Deerfield, Massachusetts), Mitchel and Charles Cook (descendants of Louis Cook, a St. Regis trustee who was born in Saratoga and whose mother was a St. Francis Abenaki), Lewis Doublehouse (a St. Regis chief) and Peter Tarbell (a descendant of Lesor Tarbell, who was captured in Groton, Massachusetts). The interpreters were William L. Gray (son of William Gray, who was

captured and taken to Caughnawaga) and Eleazer Williams (son of Thomas Williams). Eleazer, as stated in previous chapters, had motives of his own for helping negotiate the treaties. The governor of New York was DeWitt Clinton. Michael Hogan should not be forgotten either; he is the white man who had leased the 144 acres in Hogansburg from the St. Regis in 1817 to operate the ferry and eventually sold it to the State of New York (as did the St. Regis). He also served as a "witness" to some of the previous treaties with the state.

On June 13, 1825, the State of New York conveyed the "mile square" known as Massena and the mill on the Grass River to Lemuel Hascall. This conveyance is based on the treaty of March 16, 1824. However, there is no deed from the St. Regis to the State of New York conveying the land. The deed to Lemuel Hascall can be found in the St. Lawrence County clerk's office.[41] DeWitt Clinton, governor of New York, signed the patent to Lemuel Hascall. Not too long afterward, the St. Regis contested the legality of this conveyance.

On September 23, 1825, another treaty was held in Albany between the St. Regis and the State of New York.[42] The treaty was between "DeWitt Clinton Governor of the State of New York and Thomas Williams, Mitchel Cook, Lewis Doublehouse, Peter Tarbell, Michael Tarbell, Louis Tarbell, Beltice [*sic*, cursive unreadable] Tarbell, Jarvis Williams, and William L. Gray chiefs and trustees of the tribe of Indians called the St. Regis." It conveyed to the State of New York 840 acres along the St. Regis River that abuts the 1,000 acres allegedly conveyed on June 12, 1824.

Although some of the above men could speak a little English, none of them could read or write it, as evidenced by their marks next to their names, which were written by someone else. It was sealed and delivered in front of Simeon De Witt (surveyor general), Isaac Denniston (who also witnessed

St. Lawrence County showing the St. Regis reservation, 1895. *David Rumsey Map Collection.*

Survey of land ceded by the St. Regis Indians to the State of New York in 1825, containing 888.66 acres. *DEC Division of Lands and Forests, 1885. New York State Archives.*

some of the Oneidas treaties) and Isaac Seymour (it would be interesting to see if he was the same Isaac Seymour of New York who was the first president of the Bank of North America), all of whom represented the state. De Witt, Denniston, Seymour and Governor Clinton were the only witnesses for the treaty. No one from the United States was present on behalf of the Indians. The men then gave witness to what would now be called a deed and swore before commissioner of New York Garret Denniston (son of Isaac Denniston), "who was authorized to take the acknowledgement of Deeds," that the St. Regis chiefs and trustees had signed it.

Based on this, I would guess that there was no one present who was honest enough to tell the St. Regis exactly what they were signing, despite the fact that they could not read it for themselves. The beginning of the document says, "At a treaty held," but by the time it gets to the acknowledgement section of the document, like the previous treaties of 1824, it is called a deed. As stated many times, a treaty and a deed are two different things. There are no deeds recorded in St. Lawrence or Franklin Counties conveying this land. The treaty can be found at the New York State Archives.

It is hard to view this treaty, and the prior treaties from 1816 to 1824, as legal. The St. Regis had no representation and no one present—except those from the state—to read and explain to them exactly what they were signing.

As with the other treaties, the St. Regis most likely assumed or were told it was a lease. The St. Regis trustees had no clue that the men from the state would change the ending of the document, after the trustees had signed, and declare it a deed. It's no wonder that ever since this time, all the treaties with the State of New York are contested.

6
THE TREATY OF 1845

THE GRASSY MEADOWS

B efore entering into the treaty of 1845 between New York State and the St. Regis, the 1838 federal treaty with the "New York Indians" should be briefly mentioned to keep things in their proper order. The 1838 treaty will be discussed in detail in the next several chapters.

The 1838 treaty was held at Buffalo Creek and was designed to remove all Indian tribes west of the Mississippi. The special provision for the St. Regis in that treaty was land granted by patent to Eleazer Williams and his wife. He is the only signature under "St. Regis Indians" on the treaty held on January 15, 1838, signing as their chief and agent. A supplemental treaty was done the following month at St. Regis that stated, "The Government shall not compel them to remove," which was signed by members of the tribe. The amendments to that treaty were also agreed to by the St. Regis and included that "the St. Regis Indians shall not be compelled to remove under the treaty or amendments, Dated October 9th, 1838." However, the federal government and the state had every intention of compelling all the Indians to move west.

The treaty between the State of New York and the St. Regis Indians on February 21, 1845, is a perfect example of what happens when standard practices of conveying land are not followed.[43] Following the treaty of 1796, surveyor general Simeon De Witt stated in his report that he had successfully surveyed the six miles square tract, plus the two tracts of one mile square each on the Grass River and the Salmon River by the mills. However, the treaty of 1796 did not give any description as to what the "meadows on both sides of the Grass River" meant in measurements.

Grass River. *Photo by C. Amrhein, 2015.*

De Witt was about to survey the meadows along the Grass River when he was informed that the St. Regis were in council concerning the matter. The St. Regis informed him that the lands on both sides of Grass River reserved to them were to be tracts of half a mile each. De Witt planned to follow the words of the treaty verbatim and was going to survey only the grass barely along the shore of the river. The chiefs then informed De Witt that he was not allowed to make any marks on the ground or survey the parcel until they settled the matter in Albany. Because of this, Simeon De Witt's map does not contain survey lines along the river. A portion of his report of January 14, 1800, concerned the Grassy Meadows:

> *Not being permitted to make a survey of the meadows, I availed myself of the opportunity of going up and down the river, of making an estimate of them, with a view to report the same as an article of information that might be serviceable in case a compromise respecting them should be contemplated.*
>
> *These meadows consist of narrow strips along the margin of the river, where inundations have prevented the growth of timber. They lie in a number of patches, of from half a chain to three or four chains in width,*

Left to right: Mary Adams and her sister Margaret Terrance selling their basketry. Mary became the best-known basket maker of her generation. *Akwesasne Cultural Center.*

making in the whole extent, which is about six miles, not exceeding sixty acres altogether, as nearly as I could judge.

The grass on them, with small exceptions, is all wild grass. Their value, though of no very great consideration as an appendage to the adjoining lands, is however esteemed as almost inestimable by Indians, who consider the clearing of land as a matter entirely beyond their power to accomplish. It will be impossible, moreover, that the Indians should ever enclose the meadows with fences so as to prevent their destruction by the cattle of the white inhabitants, who soon will settle thick in their neighborhood, and this will inevitably become the cause of disagreeable differences.

It is proper for me to observe that the ground on which these meadows are situated, as well as the mile square at the mill on Grass River, has been patented in tracts distinct from Macomb's purchase: and therefore their sanction which the proprietors of that purchase gave to the treaty, will not exonerate the state from the duty of compensating the owners of the lands from which these parts of the reservation are taken.[44]

The St. Regis had always claimed the meadows along the Grass River. It was agreed to and confirmed to be theirs by the treaty of 1796 and reserved out of the Macomb Purchase. De Witt's statement makes it clear that it was

now the state's problem that patents had been previously issued and the state's responsibility to clear the matter up. Acts were passed in 1801 and 1802 that granted permission to treat with the Indians on the matters of the mill on Grass River and the Grassy Meadows, but not much progress was made to resolve the land dispute. This matter carried on for over forty years, as letters on encroachment from both the St. Regis and the settlers were continually sent to the legislature.

"An Act in Relation to Certain Tribes of Indians" was passed on May 25, 1841, to make the treaty process easier for the state. It authorized the commissioners of the land office to "make any treaties, contracts, or arrangements with any tribe or nation of Indians or with any party or portion of them, or with any individual Indian or Indians who have any claims upon any lands in this State for the purchase of any portion of such lands as the said Commissioners may deem just and proper."[45]

Clearly, New York state decided that with future treaties, it did not care if the representative was a chief, trustee or anyone with authority. As long as someone from one of the tribes signed the treaties, it was good enough for the state. This is inconsistent with federal law and the Nonintercourse Act and is in direct conflict with the federal government's goals elsewhere in the state concerning Indian-owned land. United States officials may not have known about this treaty taking place, as there was no one present from the United States government at the signing of this treaty, as was required by federal law.

The treaty of 1845 is between the St. Regis Indians and the commissioners of the land office on behalf of the people of the State of New York. Since the land had never been surveyed, it was agreed that the St. Regis would get three dollars per acre. This not only included the meadows on both sides of the water but also any islands in the water. After the survey was completed, the surveyed area contained 210.4 acres and was approximately 7 miles long. In this case, it was the three trustees—Mitchel Tarbell, John Swamp and Thomas Tarbell—who signed (with a Xs) the treaty. The clerk of the St. Regis, Michael Gareault and their interpreter Peter Gray also signed it. The signatures from the commissioners of the land office were A. Gardiner, lieutenant governor; N.S. Benton, secretary of state; A.C. Flagg, comptroller; Nathaniel Jones, surveyor general; and Benjamin Enos, treasurer. It was signed in the presence of Isaac Denniston.

As with the other treaties with the State of New York, I still have the same opinion. I question their validity because a representative from

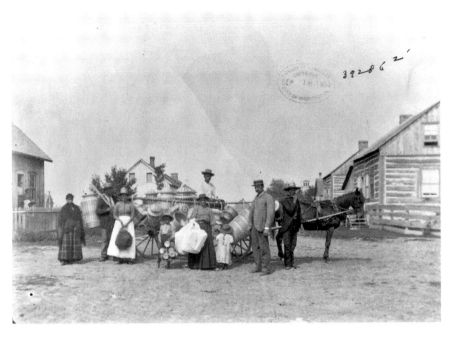

St. Regis Indians carrying baskets to the trading village. P. Daly Jr. is the basket buyer, 1894. *Library of Congress.*

the federal government wasn't present, and there were no impartial witnesses to the signing. Although there was an interpreter for the spoken word, did the trustees understand in black and white that they were selling and not leasing the land?

In this case, the trustees did sign it, but it now raises questions about the signing of treaties by other tribes in New York State after 1841. With a state-created land office commission that accepted the signature of any Indian to sign a treaty and consider it valid by the state, whether or not he was given authority to do so by his tribe's government or if he understood the written words, do we really know who signed the treaties with the state on behalf of any Indian Nation after 1841? I think it would be revealing to look at all treaties between the State of New York and the Indians to scrutinize the signature section to see if any of the historical names of the Indians' chiefs or trustees are recognizable.

The SENECA LANDS AND MARY JEMISON

LEAD UP TO THE CANANDAIGUA TREATY

N ew York was not always the size it is today. Aside from Indian villages and a few forts along the water, it was mainly unoccupied by white men. In a treaty held at Fort Stanwix in 1784, the agreed-upon lands of the Five Nations were as follows:[46]

> ARTICLE *III.*
> *A line shall be drawn, beginning at the mouth of a creek about four miles east of Niagara, called Oyonwayea, or Johnston's Landing-Place, upon the lake named by the Indians Oswego, and by us Ontario; from thence southerly in a direction always four miles east of the carrying-path, between Lake Erie and Ontario, to the mouth of Tehoseroron or Buffaloe Creek on Lake Erie; thence south to the north boundary of the state of Pennsylvania; thence west to the end of the said north boundary; thence south along the west boundary of the said state, to the river Ohio; the said line from the mouth of the Oyonwayea to the Ohio, shall be the western boundary of the lands of the Six Nations, so that the Six Nations shall and do yield to the United States, all claims to the country west of the said boundary, and then they shall be secured in the peaceful possession of the lands they inhabit east and north of the same, reserving only six miles square round the fort of Oswego, to the United States, for the support of the same.*[47]

The Ohio River being the western bounds of the Five Nations was further clarified in the treaty at Fort Harmar on January 9, 1789.[48] This treaty also

Grand Falls at Niagara from near the observatory, Goat Island, July 22, 1846, by Michael Seymour. *Library of Congress.*

included the Tuscaroras.[49] Despite these treaties with the United States, other parties were interested in the settlement of the western part of New York State. Massachusetts and New York had a long-standing disagreement, since before the Revolutionary War, about who held the rights to the land in the western territory beyond the Hudson River, aside from the Indians, that would eventually be included in the bounds of New York. They settled their disagreement in 1786 at Hartford, Connecticut. New York had the governing rights, and the Commonwealth of Massachusetts retained the right to sell the land and the preemptive rights from the Indians.[50] A copy was laid before Congress, read and recorded with the Office of the Secretary of State. Excerpts in regard to the land are as follows:

Monday, October 8, 1787.
Whereas it appears by the journals of Congress that a federal court has been instituted pursuant to the Articles of Confederation and perpetual Union to hear and determine a controversy respecting territory between the States of Massachusetts and New York; and whereas it appears by the representations of the delegates of the said states in Congress that the said

controversy has ceased and the same has been settled and determined by an Agreement entered into on the sixteenth day of December last by the agents of the said states and any further proceedings in or relative to the aforesaid court having become unnecessary.

Resolved. That all further proceedings in and relative to the said federal court as also the commissions of the judges thereof cease and determine.

A motion was then made by Mr. [Nathan] *Dane seconded by Mr.* [Abraham] *Yates that the attested copy of the aforesaid agreement laid before Congress by the delegates of the two states be filed in the secretary's Office…*

Now therefore know ye that the underwritten Commissioners on the part of the Commonwealth of Massachusetts and the State of New York respectively having by mutual consent assembled at the City of Hartford in the State of Connecticut on the thirtieth day of November last in order to the due execution of their respective trusts and having duly exchanged and considered their respective powers and declared the same legal and sufficient after several conferences and to the end that all interfering Claims and controversies between the said Commonwealth of Massachusetts and the said State of New York as well in respect of jurisdiction as property may be finally settled and extinguished and peace and harmony forever established between them on the most solid foundation, Have agreed and by these presents Do mutually for and on behalf of the said Commonwealth of Massachusetts and the said State of New York, by whom respectively they, the said Commissioners have been so appointed and authorized as aforesaid agree to the mutual Cessions, Grants, Releases, and other Provisions following, that is to say

First, the Commonwealth of Massachusetts doth hereby cede, grant, release and confirm to the State of New York forever all the claim, right and title which the Commonwealth of Massachusetts hath to the Government, sovereignty and jurisdiction of the lands and territories so claimed by the State of New York as herein before stated and particularly specified,

Secondly, the State of New York doth hereby cede, grant release and confirm to the said Commonwealth of Massachusetts and to the use of the Commonwealth their Grantees and the heirs and Assigns of such Grantees forever the right of preemption of the soil from the native Indians and all other the estate, right, title and property (the Right and title of Government, sovereignty and jurisdiction excepted) which the State of New York hath of in or to two hundred and thirty thousand and four hundred Acres to be located by the Commonwealth of Massachusetts…

Thirdly, The commonwealth of Massachusetts doth hereby cede, grant, release and confirm to the State of New York and to the use of the State of New York their grantees and the Heirs and Assigns of such grantees forever, the right of preemption of the soil from the native Indians, and all other the Estate right, title and property, which the commonwealth of Massachusetts hath, of, in, or to the residue of the lands and territories so claimed by the State of New York as herein before stated, and particularly specified...

Fourthly, that the lands so ceded, granted, released and confirmed to the commonwealth of Massachusetts, or such part thereof as shall from time to time be and remain the property of the commonwealth of Massachusetts, shall during the time that the same, shall so be and remain such property be free and exempt from all taxes whatsoever, and that no general or State tax, shall be charged on, or collected from the lands hereafter to be granted by the commonwealth of Massachusetts or on the occupants or proprietors of such lands, until fifteen Years after such confirmation as is herein after mentioned of such grants shall have expired, but that the lands so to be granted, and the occupants thereof shall during the said period be subject to town or county charges or taxes only; provided that this exemption from general or state taxes, shall not be construed to extend to such duties, excises or imposts to which the other Inhabitants of the State of New York shall be subject and liable.

Fifthly, That no rents or services shall be reserved in any grants to be made of the said lands by the commonwealth of Massachusetts.

Sixthly, That the Inhabitants on the said lands and territories being citizens of any of the United States, and holding by grants from the commonwealth of Massachusetts, shall be entitled to equal rights with the other citizens of the State of New York, and further that the citizens of the commonwealth of Massachusetts, shall from time to time and at all times hereafter have and enjoy the same and equal rights respecting the navigation and fishery on and in lake Ontario and lake Erie, and the waters communicating from the one to the other of the said lakes, and respecting the roads and portages between the said lakes as shall from time to time be had and enjoyed by the citizens of the State of New York, and the citizens of the commonwealth of Massachusetts shall not be subject to any other regulations or greater tolls or duties to be made or imposed from time to time by the state of New York respecting the premises, than the citizens of the State of New York shall be subject to.

Seventhly, That no adverse possession of the said lands for any length of time shall be adjudged a dissension of the commonwealth of Massachusetts.

Eighthly, That the State of New York so long as any part of the said lands, shall be and remain the property of the commonwealth of Massachusetts, shall not cede, relinquish or in any manner divest themselves of the government and jurisdiction of the said lands or any part thereof without the consent of the commonwealth of Massachusetts.

Ninthly, That the commonwealth of Massachusetts may from time to time by persons to be by them authorized for the purpose hold treaties and conferences with the native Indians relative to the property or right of soil of the said lands and territories hereby ceded, granted, released, and confirmed to the commonwealth of Massachusetts, and with such armed force, as they shall deem necessary for the more effectual holding such treaty or conference; and the commonwealth of Massachusetts within six months after such treaties, shall respectively be made, shall cause copies thereof to be deposited in the office of the Secretary of the State of New York.

Tenthly, The commonwealth of Massachusetts may grant the right of preemption of the whole or any part of the said lands and territories to any person or persons who by virtue of such grant shall have good right to extinguish by purchase the claims of the native Indians, provided, however, that no purchase from the native Indians by any such grantee or grantees, shall be valid unless the same shall be made in the presence of and approved by a Superintendent to be appointed for such purpose by the commonwealth of Massachusetts, and having no interest in such purchase, and unless such purchase shall be confirmed by the commonwealth of Massachusetts.

Eleventhly, That the grantees of the said lands and territories under the commonwealth of Massachusetts shall within six months after the confirmation of their respective grants, cause such grants or the confirmations thereof or copies of such grants or confirmations certified or exemplified under the seal of the commonwealth of Massachusetts to be deposited in the said Office of Secretary of the State of New York, to the end that the same may be recorded there, and after the same shall have been so recorded, the grantees shall be entitled to receive again from the said Secretary their respective grants or confirmations, or the copies thereof, whichsoever may have been so deposited without any charges or fees of Office whatsoever, and every grant or confirmation, which shall not, or of which such copy, shall not be so deposited, shall be adjudged void…done at the city of Hartford aforesaid, the sixteenth day of December in the Year of our Lord one thousand seven hundred and eighty six, and the eleventh Year of the Independence of the United States of America.[51]

The Hartford Compact was notarized on January 13, 1787. Some of the parties present you will recognize from previous chapters: Robert R. Livingston, Jeremiah Wadsworth and Simeon De Witt. It was originally recorded on February 2, 1787, in the United States Office of the Secretary of State in Miscellaneous Records, book A, beginning on page 38 and is now held at the Massachusetts Archives.

It is a rather long document, to be sure, but it is important to note the wording used. Much of it is wording you would find on a deed. Why? Because the point of the document is land. It uses the standard wording for land conveyance: grantee (buyer), grantor (seller), ceded, granted, released and use of, to name a few. Massachusetts would transfer its preemptive rights of the Indian land to whomever was the purchaser, provided Massachusetts agreed and a representative was present at any treaty conducted with the Indians. Land grants are like deeds—they convey land. Massachusetts required the grantees of the said land to record their grants with the secretary of the State of New York within six months or it would be considered void, the same as all deeds are to be recorded in a county clerk's office. Remember, we are talking about land that had not been settled by the white man yet, so there were no county clerk's offices scattered throughout Western New York as there are today.

New York agreed with these terms. Clearly, New York understood what the rules of land transfer were before any land was ever conveyed to land companies or settlers. George Washington had previously made it clear that a United States representative must be present at any treaty with the Indians. Massachusetts made it clear that it must have a representative present as well for any agreements about land in the disputed area. All parties knew the importance of recording any land transaction to prove legal ownership. This agreement, as stated before, was recorded in some of the original Western New York counties when they were formed in order to show the chain of title on the land back to the beginning.

Oliver Phelps and Nathaniel Gorham both wanted the large tract of land. Rather than compete with each other, as well as other investors vying for it, they joined forces and resources for the purchase of the entire parcel from the preemptive line (Sodus Bay) to Lake Erie. In July 1788, Phelps and Gorham and the Five Nations of Indians held a treaty at the Buffalo Creek Reservation at which Red Jacket, Handsome Lake, Cornplanter, Farmer's Brother and Heap of Dogs were present.[52] Phelps and Gorham were only able to secure the preemptive rights from the Indians as far as the Genesee River. A letter among the records of the Pennsylvania State Archives mentions the purchase:

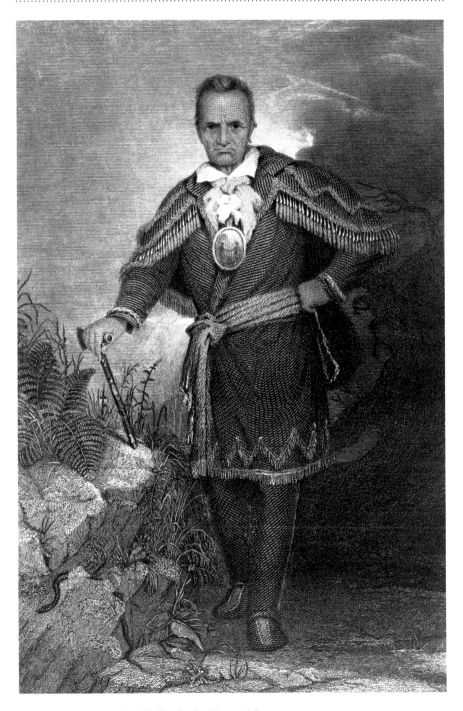

Red Jacket engraving by M.J. Danforth. *Library of Congress.*

Quaker Friends Indian School, circa 1900. *Cattaraugus County Historical Museum.*

Letter to Messer Mitten
New York, 26ᵗʰ Jan'y, 1789.
Sir,
I have the honor of writing you a very few lines shortly after my arrival. Mr. Gorham having arrived since, we have five states, and every reason to expect there will be seven in a week or ten days.
* The purchase made of the Indians by Mr. Gorham &C., (part of the whole purchase of the state) begins at or 82d mile stone, and runs along our N. lin to the 124ᵗʰ, and then runs due N. to the great fork of the Genesee River.*
Tench Coxe.
[Penn. Arch., xi, 539–540.][53]

Unfortunately for them, Phelps and Gorham were unable to make the required payment to Massachusetts the following year for the entire parcel. They were only able to keep the land where the Indian title had been extinguished. Basically, everything west of the Genesee River, minus what was known as the "Mill Tract," reverted back to Massachusetts. The land the two men retained is known as the "Phelps & Gorham Purchase." Oliver and Nathaniel immediately set out to survey the land.

Robert Morris next purchased the preemptive rights from Massachusetts for the reverted land. He then turned around and sold it to the Holland Land Company, subject to extinguishing the Indian title but reserving to

himself a strip called the "Morris Reserve." (An error was also found in the original survey, causing the line between the western side of the Phelps & Gorham Purchase and the east line of the Holland Land purchase to be twelve miles apart by the time it reached the most northern point. This is called "the gore." When the line was resurveyed, the gore consisted of over eighty-four thousand acres.) Negotiations began in order to hold a treaty in to extinguish the Seneca Indians' title to the land.

TREATY WITH THE SIX NATIONS, 1794. (Canandaigua)
Nov. 11, 1794. | 7 Stat., 44. | Proclamation, Jan. 21, 1795.[54]
ARTICLE II.
The United States acknowledge the lands reserved to the Oneida, Onondaga and Cayuga Nations, in their respective treaties with the state of New-York, and called their reservations, to be their property; and the United States will never claim the same, nor disturb them or either of the Six Nations, nor their Indian friends residing thereon and united with them, in the free use and enjoyment thereof: but the said reservations shall remain theirs, until they choose to sell the same to the people of the United States, who have the right to purchase.

ARTICLE III.
The land of the Seneka nation is bounded as follows: Beginning on Lake Ontario, at the north-west corner of the land they sold to Oliver Phelps, the line runs westerly along the lake, as far as O-yōng-wong-yeh Creek, at Johnson's Landing-place, about four miles eastward from the fort of Niagara; then southerly up that creek to its main fork, then straight to the main fork of Stedman's creek, which empties into the river Niagara, above fort Schlosser, and then onward, from that fork, continuing the same straight course, to that river; (this line, from the mouth of O-yōng-wong-yeh Creek to the river Niagara, above fort Schlosser, being the eastern boundary of a strip of land, extending from the same line to Niagara river, which the Seneka nation ceded to the King of Great-Britain, at a treaty held about thirty years ago, with Sir William Johnson); then the line runs along the river Niagara to Lake Erie; then along Lake Erie to the north-east corner of a triangular piece of land which the United States conveyed to the state of Pennsylvania, as by the President's patent, dated the third day of March, 1792; then due south to the northern boundary of that state; then due east to the south-west corner of the land sold by the Seneka nation to Oliver Phelps; and then north and northerly, along Phelps's line, to the

Chief Norman Parker in 1949 holding the original Pickering (Canandaigua) Treaty of 1794. *Floyd H. Benham Collection, Tonawanda Indian Reservation Historical Society.*

place of beginning on Lake Ontario. Now, the United States acknowledge all the land within the aforementioned boundaries, to be the property of the Seneka nation; and the United States will never claim the same, nor disturb the Seneka nation, nor any of the Six Nations, or of their Indian friends residing thereon and united with them, in the free use and enjoyment thereof: but it shall remain theirs, until they choose to sell the same to the people of the United States, who have the right to purchase…

NOTE. It is clearly understood by the parties to this treaty, that the annuity stipulated in the sixth article, is to be applied to the benefit of such of the Six Nations and of their Indian friends united with them as aforesaid, as do or shall reside within the boundaries of the United States: For the United States do not interfere with nations, tribes or families, of Indians elsewhere resident.[55]

Although this treaty clearly states the reservations to be their property, which the United States would never seek to claim, nor disturb them, this, of course, was not the case, as the quest for more land and the push farther west continued.

8

THE TREATY AT BIG TREE AND MARY JEMISON

Much has been written, both fact and fiction, about Mary Jemison, also known as the "White Woman of the Genesee." The most acclaimed version is the account written by James E. Seaver of Pembroke, New York, but it certainly wasn't the first. An earlier account of her life was written on October 20, 1820, in part of a letter written by Reverend Timothy Alden to Reverend Abiel Holmes in Meadville, Pennsylvania. He writes to tell of his work among the Munsees and Senecas from August 23 to October 5. This means the public was already aware of Alden's work and Mary Jemison's life as of 1821, which predates Seaver's book. Reverend Alden's letters were published in book form in 1827.[56]

Reverend Alden's excerpt on Mary appeared in the October 10, 1821 issue of the *Dutchess Observer*, out of Poughkeepsie, New York. It was reprinted from the *National Intelligencer*, published in Washington, D.C. In Alden's account, he says Mary was of Scottish descent but that her parents had come from Northern Ireland. She was born in Marsh Creek, Pennsylvania, below Konnegocheague, to Thomas and Jane (Irvine) Jamieson. In this account, she was captured in 1758 at the age of thirteen, along with her family. In comparison, it seems Seaver borrowed much of Alden's account and expanded upon it and included the negotiation for the sale of Mary's land. In Alden's text, he describes Mary's land as "one of the fertile bottoms of the Genesee, flanked by high, abrupt, and romantic banks." He then goes on to describe the beautiful falls at what we now call Letchworth State Park. The Genesee River ran through the Gardeau Reservation in what is now also part of Letchworth State Park:

From the White Woman's Tract, as the reservation about Gauhdaou [sic] is called, we set our faces for Weskoi, on another reservation still further up the Genessee. On our way, we turned aside to view a great natural curiosity, little frequented, and, probably, never before described, the falls in the river at Nunda. With some difficulty we descended a precipitous bank, and passed over a bottom to the margin of the river, where we stood upon a solid shelving rock, and looked down the frightful chasm. We saw before us the sheet of water falling ninety-six feet upon a rocky bed, from which the spray rose, in a thick mist, and exhibited a well defined rainbow. Two other falls are above, and within a mile and a half of the one we visited. At the uppermost, the whole river has a perpendicular descent of sixty-seven feet, and, at the intermediate fall, that of one hundred and ten feet, as we were credibly informed. The want of time, with the inconvenience of access, prevented us the gratification of beholding more than one of these three cataracts, which in time of a high rise of water must be awfully tremendous.

The area known as "High Banks" on the Genesee River near Mount Morris, New York, circa 1895. It is now part of Letchworth State Park. *Library of Congress.*

One has to wonder if it was the description of her land printed in 1821 that was the catalyst that created the life of Mary Jemison as written by Seaver. In 1823, Seaver was commissioned by a publisher to travel to the home of Mrs. Jennet Whaley in Castile, Wyoming County. There he was to meet Mary Jemison and write the history of her life as dictated by herself. Mary supposedly traveled on foot from Gardeau to Whaley's Tavern with Thomas Clute, who in the book is referred to as her "protector." In reality, he was an attorney and the brother of Jellis Clute, one of the men who ended up with her land. According to the book, her account was taken down on November 29, 1823. Seaver states that Mary's parents and siblings set sail in 1842 or '43 from Ireland on the ship *Mary William* and that Mary was born en route to Philadelphia. They were captured in Marsh Creek in 1755. No record of such a ship has been found. By a news account printed in the *New York Gazette* (as well as the *New York Mercury*), the date of capture is verified:

> *The New York Gazette*
> *April 17, 1758*
> *Extract of a Letter from York County, dated the 5ᵗʰ Instant.*
> *"Three Indians were seen this Day by two Boys near Thomas Jamieson's, at the Head of Marsh Creek; upon which they gave the Alarm, when six Men went to said Jamieson's House, and found there one Robert Buck killed and scalped; also a horse killed, that belonged to William Man, a Soldier at Carlisle, whose Wife and Children had just come to live with Jamieson. This Woman, and her three Children, Thomas Jamieson, his Wife, and five or six Children, are now missing. The same Day, a Person going to Shippen's Town, saw a Number of Indians near that Place, and imagined they designed to attack it.—This has thrown the Country into Great Confusion."*

Seaver's story was first published in pamphlet form in Canandaigua in 1824 and was entitled *A Narrative of the Life of Mrs. Mary Jemison*. There have been many editions since then, with new information added in an appendix. It is unknown how much of Seaver's input is reflected in this history. I find some of the language similar to the author's, but it is the closest account of Mary's life, and I would say, for the most part, it is accurate.

Mary eventually ended up at a Seneca village and was given to two Indian women there. She was given the name Dickewamis, meaning "pretty girl" or "handsome girl." Shortly after that, she married a Delaware Indian named Sheninjee. Her first child, a girl, died prematurely. She then bore her husband a son, whom she named Thomas.

Left to right: Dr. W. Clifford Shongo (Seneca) and William F. Eddy removing graves for reburial at the Cattaraugus reservation before the building of Mt. Morris Dam, 1949. *F.H. Benham Collection, Tonawanda Reservation Historical Society.*

Mary and Thomas traveled by foot in 1759 to join her Indian family by the Genesee River. By this time, her son, Thomas, was about four years old. Her husband was to meet her there but had died on the way. Mary then married an Indian named Hiokatoo, who was sometimes called Gardow. Mary had six children by her second husband. Her sons Thomas and Jesse were killed by the hand of another brother, John. John himself also died a violent death. Her daughters were named Nancy, Betsy, Polly and Jane, who died in August 1797 before the Treaty at Big Tree at the age of fifteen.

Mary's land had been granted to her prior to the 1797 treaty. Before her Indian brother, Kaujisestaugeau, left for Canada, he told Mary he would speak to the chiefs at the council at Buffalo Creek. When the time came for the treaty, she would be conveyed a tract of land of her choosing.

The Treaty at Big Tree was arranged to extinguish the title to the land reserved to the Seneca, whose territory was all of Western New York. The treaty was held on September 15, 1797.[57] Mary Jemison was sent for by Farmer's Brother to attend the Treaty at Big Tree. He spoke on her behalf, requesting the area of land that she had described to him, which

included Gardeau. Despite Red Jacket's objections, the Senecas granted the land to her.

The attendees at this treaty were James Wadsworth on behalf of the United States and himself, of course, as he already owned large tracts in the Phelps & Gorham Purchase and would end up with large tracts of this land as well, and Thomas Morris on behalf of his father, Robert Morris, who was at this time hiding out from debt collectors over his loss

A transit, a surveyor's instrument similar to the one used by Joseph Ellicott. *Holland Land Office Museum.*

during the delays of treaty negotiations and funding for the Revolutionary War. Jasper Parrish (an Indian land agent) and Horatio Jones served as interpreters. All of these men had motives of their own, and all would get a slice of the pie. The treaty was witnessed by Nat. W. Howell; Joseph Ellicott and Israel Chapin, both surveyors who ended up with several tracts; James Rees; Henry Aaron Hills; and Henry Abeel, also known as Cornplanter. Fifty-two Senecas were in attendance, including Young King, Handsome Lake, Farmer's Brother, Red Jacket, Little Billy, Pollard, Thomas and John Jemison and Little Beard (many of whom are buried at Forest Lawn Cemetery in Buffalo).

The treaty was made to acquire all the Seneca lands, minus land for their established villages or designated reservations. Since there had been no survey yet, the reservations were agreed upon in general terms of square miles or acres. When it came time for Mary to describe the land she was promised by the Senecas, she described it in visual terms. Since it was assumed the area she wanted was only a few hundred acres, everyone agreed to it, and based on her description, it was written into the treaty.

The description from the treaty for Gardeau flats is on the next page, along with other land retained by the Seneca. The current spellings of these reservations are in brackets.

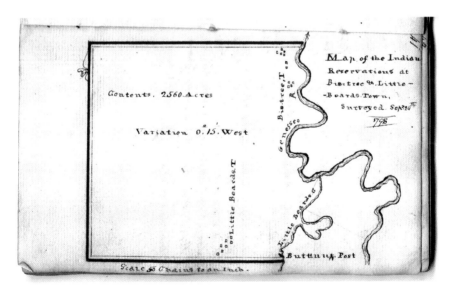

Survey of Big Tree and Little Beard Reservations by Augustus Porter, surveyor, 1798. From a Holland Land Company surveyor's field notes. *New York State Archives.*

1797 Big Tree Treaty
AGREEMENT WITH THE SENECA, 1797. (Excerpts)
Sept. 15, 1797. | 7 Stat., 601.
Contract entered into, under the sanction of the United States of America, between Robert Morris and the Seneca nation of Indians.

 Canawaugas [sic] *of two square miles*
 Big Tree of two square miles,
 Little Beard's town extending one mile along the river,
 Squawky Hill two square miles,
 Gardeau, beginning at the mouth of Steep Hill creek, thence due east until it strikes the old path, thence south until a due west line will intersect with certain steep rocks on the west side of Genesee river, then extending due west, due north and due east, until it strikes the first mentioned bound, enclosing as much land on the west side as on the east side of the river [emphasis added].

 Kaounadeau [Caneadea] *extending in length eight miles along the river and two miles in breadth.*

 Cataraugos, [Cattaraugus] *beginning at the mouth of the Eighteen mile or Koghquaugu creek, thence a line or line to be drawn parallel to lake Erie, at the distance of one mile from there, to the mouth of Cataraugos creek, thence a line or lines extending 12 miles up the north side of said creek at the distance of one mile therefrom, thence a direct line to the said creek, thence down the said creek to lake Erie, thence along the lake to the first mentioned creek, and thence to the place of beginning. Also one other piece at Cataraugos, beginning at the shore of lake Erie, on the south side of Cataraugos creek, at the distance of one mile from the mouth thereof, thence running one mile from the lake, thence on a line parallel thereto, to a point within one mile from the Connondauweyea creek, thence up the said creek one mile, on a line parallel thereto, thence on a direct line to the said creek, thence down the same to lake Erie, thence along the lake to the place of beginning.*

 near the Allegenny river forty-two square miles
 Buffalo and partly at the Tonnawanta creeks, two hundred square miles.[58]

It should be noted briefly that the Cattaraugus Reservation, as it was set out above, was broken into two parcels. The Senecas were not agreeable to this. This was corrected to a single reserve by a treaty at Buffalo Creek in 1802.[59] It was also corrected by deed. The land description explains that the Seneca Nation deeded back two parcels in consideration for one. It is

A surveyor's chain used by Joseph Ellicott to survey the Holland Purchase. *Holland Land Office Museum.*

filed in the Genesee County clerk's office.[60] This is another example showing that the parties involved knew the proper method for land conveyance. The reservations indicated on the map of *Indian Land Cessions in the United States, 1784–1894* are as follows: 30, Canawaugus; 31, Big Tree; 32, Little Beard's; 33, Squawky Hill; 34, Gardeau; 35, Caneadea; 36, part of former Cattaraugus relinquished in 1802; 37, part of former Cattaraugus relinquished in 1802; 38, Allegany; 39, Buffalo Creek; 40, Tonawanda; 41, Oil Spring; and 45, new Cattaraugus.

The deed to Mary Jemison from the Chief Warriors and Chief Sachems of the Seneca Nation was dated 1797 and recorded in the Ontario County clerk's office on October 13, 1798.[61] This volume can now be found at the Ontario County archives. The land description reads as follows:

> *one certain parcel or tract of land being and lying on the Genesee River, then extending due west, due north, and due east till it strikes the first mentioned bounds including as much land upon the west side as it does on the east side of said river.*

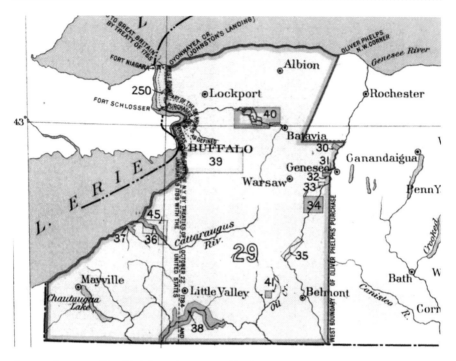

A map of western New York from the report of Indian Land Cessions in the United States, 1784–1894. *Library of Congress.*

The description is rather vague, but at this point, the land hadn't been surveyed yet. This is a warranty deed, meaning the grantor will forever warrant and defend that the title is forever hers and so to her heirs.

In 1798, Augustus Porter surveyed the Gardeau parcel. To the great surprise of all, the parcel was much larger than the few hundred acres that Robert Morris had assumed. By Morris agreeing to Mary's vague description, she managed to secure herself 17,929 acres. This survey is part of the collection of the New York State Archives and can also be viewed online at the New York State Archives' Digital Collections website.[62]

Mary often leased some of her land, primarily to Micah Brooks and Jellis Clute. Since this had never been agreed to by the United States government or the Seneca chiefs, they did not hold clear title to the land. In 1817, they began steps to make Mary a United States citizen so she could legally convey the land. Seaver does mention this in his book, and it can be verified by government documents. It was common for the newspapers of the day to publish the New York State legislative acts. Seaver is correct on Mary's citizenship. The act was called "An Act

A map of the Gardeau reservation by August Porter, surveyor, 1798. From a Holland Land Company surveyor's field notes. *New York State Archives.*

for the relief of Mary Jemison" and is noted in the *New York Commercial Advertiser* in its April 19, 1817 issue.

On April 23, 1817, Mary "Jameson" conveyed approximately seven thousand acres of the Gardeau reserve on the east side of the Genesee River to Micah Brooks and Jellis Clute. The deed is filed in the Genesee County clerk's office. The land description reads:

> *All that certain Tract or parcel of Land lying in the Town of Leicester in said County of Genesee Beginning on the North line of a Tract of Land called the Gardeau reservation and on the line of Townships between the Town of Leicester and the Town of Perry from thence to run South on the line of Townships to the South line of the S'd Gardow Reservation from thence East on the South line of said reservation to the Southeast corner of the Reservation from thence North to the Northeast corner of the S'd Tract from thence west to the place of Beginning containing the whole of the Land within the above described lines be the same more or less.*[63]

In 1819, Mary would sell another three hundred acres, this time on the west side of the Genesee River to George Jemison, whom she believed to be her cousin.[64]

In the winter of 1822–23, says Seaver, Mary was again approached by Brooks, Clute and Gibson on the matter of the remainder of her land. She agreed to convey the rest, minus what was already conveyed and a portion she'd keep for herself, if they could get the Seneca chiefs, along with a United States commissioner, to come to Moscow (a hamlet of the town of Leicester in Livingston County, New York).

In reality, they must have known by public notice that it would be put up for auction. The Gardeau Reservation was within the bounds of the Morris Reserve, which contained over fifty-eight thousand acres. After the death of Robert Morris, it had to be auctioned off to settle the debts he owed to his creditors. The auction was held at the Coffee House in New York City on May 13. Gibson was the highest bidder for 6,974 52/100 acres of the Gardeau tract at $1.22½ an acre ($8,543.15). He received his deed for the property on June 18, 1823.[65] It seems more than a coincidence that at the same time, Thomas Clute took Mary to see Seaver to publish a book on her life and help her write her will.

The council assembled at Moscow on September 3, 1823, almost three months before Jemison's oral history was said to be taken. Major Carrol had been appointed by the U.S. president and was assisted by Judge Howell,

Nathaniel Gorham, Jasper Parrish as Indian agent and Horatio Jones as interpreter. In her dictated Seaver biography, Mary said (or Seaver interpreted what she said) the bargain was made, and a deed had been executed to Henry B. Gibson, Micah Brooks and Jellis Clute for the entire remainder of the tract except a portion she reserved for herself. The amount of land reserved equaled 1,280 acres on the west side of the Genesee River. However, the treaty itself states the land was conveyed to John Greig and Henry B. Gibson and was conveyed by the Seneca for the sum of $4,286.[66] Mary's X appears next to her name on the treaty. This treaty was never ratified.[67]

As to Mary's will, it was executed on September 3, 1823—the same day as the treaty. In it, she bequeaths:

To my beloved daughters, Nancy Jamison, Betsy Jamison and Polly Jamison in equal proportions and to their heirs forever the three quarters of the principal & interest of a certain Bond & Mortgage executed by Jellis Clute and Micah Brooks for the sum of four thousand two hundred and eighty six dollars, dated September 3rd, 1823. I also give and bequeath to George Jamison, Jacob Jamison, John Jamison, Thomas Jamison 2nd,

Charles Newmann standing on the site of Mary Jemison's home on Gardeau Flats, April 1949. *F.H. Benham Collection, Tonawanda Reservation Historical Society.*

A map of the Indian reservation at Kane-audea (Caneadea) by Augusta Porter, surveyor, 1798. From a Holland Land Company surveyor's field notes. *New York State Archives.*

Jesse Jamison, Peggy White, Jane White and Catherine Jamison, the children of my beloved son Thomas Jamison deceased the other remaining one forth part.[68]

By a treaty held at Buffalo Creek on August 31, 1826, Mary Jemison allegedly conveyed the last two acres of her land at Gardeau.[69] I can find no deeds for the final transaction in Ontario, Genesee, Erie or Livingston Counties, nor is her name mentioned or her mark present in the signature section. The treaty itself, however, was recorded in the Erie County clerk's office, which is not the same as a standard land conveyance.[70]

The 1826 treaty included other reservation land as well. All of Caneadea, six square miles; Canawaugus, Big Tree and Squawky Hill, two square miles each; and a large portion of the Buffalo Creek, Cattaraugus and Tonawanda Reservations were conveyed. Mary removed to what was left of the Buffalo Creek Reservation shortly afterward to spend the remainder of her days. She died on September 19, 1833, but this was not the end of it.

The will was presented to the court. Polly, Mary's daughter, contested it and presented another one to the court that left herself and her children as

A view of the council house and Mary Jemison's statue at Letchworth State Park in Genesee Falls, Wyoming County, 1912. *New York State Archives.*

the sole heirs of all Mary's real estate, including the house on the Buffalo Creek Reservation. This will was allegedly written on May 6, 1833. It was not accepted by the court, as many came forward to provide affidavits saying that Mary's health was no longer good enough to make that kind of decision and she was blind by then. They also implied that Polly had not taken the best care of her mother. Micah Brooks and Jellis Clute also signed sworn affidavits saying they were present when the first will was executed. It took two years to probate the original will and settle the estate.

In 1855, Polly's heirs petitioned the United States Committee on Indian Affairs. It seems that a certain Indian subagent, James Stryker, who was supposed to be in charge of the annuities for the Senecas, took off with the money to the tune of $28,505.50. Polly had told them that $1,331.00 was from the bond and mortgage of her mother that was turned over to the subagent and $300.00 more of it was her own. As it turned out, this had already been reimbursed, and she should have only received a quarter of it per Mary's will.[71]

Mary Jemison was laid to rest at the Mission burial ground near Buffalo (formerly part of the Buffalo Creek Reservation) but was removed to Letchworth State Park in 1874 to the Council Grounds for burial. She had returned to her beloved home.

The REMOVAL TREATY OF 1838

9

OVERVIEW

B efore entering into the topic of the Indians' removal to Kansas, a closer look needs to be taken at the removal treaty of 1838. In doing so, we need to take a closer look at another influential yet often unmentioned figure who swayed the history of the Six Nations in New York: Eleazer Williams.

Eleazer Williams was thought of in New York as one of the great missionaries to the St. Regis and Oneidas. The other story New Yorkers loved to tell was the romanticized tale of Eleazer being the "Lost Dauphin," the heir to the throne of France, who was smuggled to North America as a child to live concealed among the St. Regis when his parents, King Louis XVI and Marie Antoinette, were beheaded. Many New York newspapers ran full steam with the story, as well as several magazine publications. After Williams induced some of the Oneidas to remove to Wisconsin in the 1820s along with him, and after his "plan" there failed, he set his sights back in New York.

He was the only one from the St. Regis, and the only one on behalf of the Mohawks collectively, to sign the removal treaty at Buffalo Creek in January 1838.[72] He also signed the treaty as "chief and agent" on behalf of the St. Regis. To the best of my knowledge, Eleazer was never a chief nor was he appointed as an agent of the tribe—he was self-appointed. In this treaty, Eleazer acquired a patent for himself and his wife in "fee simple" for land in Green Bay, Wisconsin.

Unlike in New York, published reports in Wisconsin, where Eleazer lived the majority of his life, were not so favorable. Over the years, through

Reverend Eleazer Williams. *Library of Congress.*

government documents, newspapers, magazines, records at the Wisconsin Historical Society and the Neville museum in Green Bay, the picture of Eleazer Williams is painted differently. His other life was filled with illusions of grandeur, self-adoration and schemes to create an "Indian Empire," with himself as the leader.

There are conflicting histories surrounding Eleazer's birth. One version is that he was the heir to the throne of France. The other tells of his Native American roots, being the son of Thomas Williams. As that story goes, Eleazer's father descends from Reverend John Williams of Deerfield, Massachusetts. A party of Mohawks and French soldiers took the reverend's family captive in 1704 in what is referred to as the "Deerfield Massacre." Over the course of two years, the majority of those captured were released. One daughter, Eunice Williams, preferred to remain with her captors and was adopted. It is said that she married a chief and bore three children, one by the name of Mary. Mary is the mother of Thomas Williams, father of Eleazer, who was born at Caughnawaga in about 1789. An extensive amount of research and opinions have been printed on Eleazer since the 1840s, and there is still debate about which version is correct. Either way, it is irrelevant in the larger picture. What is relevant is that Eleazer himself took advantage of both versions of his birth throughout his lifetime.

In light of Eleazer Williams being the only "representative" from the St. Regis to attend the treaty in January 1838, a supplemental article to the treaty was held at the St. Regis council house on February 13, 1838. In part, the article amended to the treaty states, "The United States will, within one year after the ratification of this treaty, pay over to the American party of said Indians one thousand dollars, part of the sum of five thousand dollars mentioned in the special provisions for the St. Regis Indians, any thing in the article contained to the contrary notwithstanding." Remember this clause. It will become very important as we cover the treaty, Eleazer Williams and the Kansas lands.

This amendment to the treaty also states, "And it is further agreed, that any of the St. Regis Indians who wish to do so, shall be at liberty to remove to the said country at any time hereafter within the time specified in this treaty, but under it the Government shall not compel them to remove." It is clear that they were under no obligation to leave if they didn't want to. The signature section to the amendment to the treaty was witnessed by "A.K. Williams, Agent on the part of New York for St. Regis Indians; W.L. Gray, Interpreter; and Owen C. Donnelly, Say Saree." It is unknown if A.K. Williams is related to Eleazer Williams.[73]

In the center of this group is the matriarch proudly holding the youngest member of her family, early 1900s. *Smoke Family Collection, Akwesasne Cultural Center.*

A census of the Indian tribes, taken in 1837, was included in the text of the treaty of 1838. The population of the St. Regis at that time was 350. The Indians who did wish to remove from New York under this treaty to the land set aside, which is now known as part of Kansas, are referred to as the "New York Indians."

This special tract was set up for the New York Indians as a result of a land claim that had already risen in Green Bay, Wisconsin, based on the Menomonee treaty of 1831. In essence, part of the treaty of 1838 was to settle a land claim on land in Green Bay, Wisconsin. The New York Indians ceded their claim to the remainder of the Wisconsin land (except the part already settled by Williams and the Indians who went along with him) in exchange for land in the Kansas territory. The description of the land from the treaty of 1838, article 2, is as follows:

In consideration of the above cession and relinquishment, on the part of the tribes of the New York Indians, and in order to manifest the deep interest of the United States in the future peace and prosperity of the New York Indians, the United States agree to set apart the following tract of country, situated directly west of the State of Missouri, as a permanent home for

all the New York Indians, now residing in the State of New York, or in Wisconsin, or elsewhere in the United States, who have no permanent homes, which said country is described as follows, to wit: Beginning on the west line of the State of Missouri, at the northeast corner of the Cherokee tract, and running thence north along the west line of the State of Missouri twenty-seven miles to the southerly line of the Miami lands; thence west so far as shall be necessary, by running a line at right angles, and parallel to the west line aforesaid, to the Osage lands, and thence easterly along the Osage and Cherokee lands to the place of beginning to include one million eight hundred and twenty-four thousand acres of land, being three hundred and twenty acres for each soul of said Indians as their numbers are at present computed. To have and to hold the same in fee simple to the said tribes or nations of Indians, by patent from the President of the United States, issued in conformity with the provisions of the third section of the act, entitled "An act to provide for an exchange of lands, with the Indians residing in any of the States or Territories, and for their removal west of the Mississippi" approved on the 28th day of May, 1830, with full power and authority in the said Indians to divide said lands among the different

Seneca bead work, circa 1850. *Cattaraugus County Historical Museum.*

tribes, nations, or bands, in severalty, with the right to sell and convey to and from each other, under such laws and regulations as may be adopted by the respective tribes, acting by themselves, or by a general council of the said New York Indians, acting for all the tribes collectively. It is understood and agreed that the above described country is intended as a future home for the following tribes, to wit: The Senecas, Onondagas, Cayugas, Tuscaroras, Oneidas, St. Regis, Stockbridges, Munsees, and Brothertowns residing in the State of New York, and the same is to be divided equally among them, according to their respective numbers, as mentioned in a schedule hereunto annexed.

Very few people from the New York tribes removed to Kansas under the treaty of 1838. In fact, the Kansas plan was a dismal failure on the part of the United States government. What happened to those who did venture to go, and what ultimately happened to the land there and the rights to it, is a story you will not be able to resist digging into on your own as the next chapters progress.

ELEAZER WILLIAMS'S INVOLVEMENT IN THE TREATIES

In 1820, with the permission of the War Department, Eleazer Williams took a delegation of Oneidas, Onondagas, Tuscaroras, Senecas and Stockbridges to the west but only made it to Detroit, where they learned that part of the land had been ceded to the United States. In 1821, he set out again for Green Bay, taking a group of fourteen Indian men. The *Detroit Gazette* reported that they arrived on the steamboat *Walk-in-the-Water* on July 12, 1821. It was later reported they left by the same ship on July 31 and arrived at Green Bay on August 5 to begin the negotiations.

The fourteen men who signed as deputies for the tribes were as follows. Deputies for the Oneida nation were Tahyentaneken, alias John Anthony; Tahnonsongotha, alias John Skenando; Onongwatgo, alias Cornelius Beard; and Sganawaty, alias Thomas Christian. The deputy for the Onondaga nation was Yawentanawen, alias Abraham Lafort. The deputies for the Seneca Nation were Dagaoyoteh, alias Jacob Jameson, and Hanasaongwas, alias George Jameson. Five men signed to represent the Stockbridge nation, or tribe of Indians of New York, and one man signed to represent the Munsee nation, or tribe of Indians (no state mentioned.) They were all authorized and empowered to represent the Six Nations, or tribes of Indians of the State of New York. The treaty states Eleazer Williams, alias Onwarenhuaki, was allegedly the deputy authorized and empowered to represent the St. Regis Indians of the State of New York. As stated in previous chapters, Eleazer Williams was not a trustee for the St. Regis. We can surmise then, since the treaty was written up by the state, that the men who were authorized and

empowered as deputies were done so by the state and not by the Indian nations represented.

We know by the treaties between the St. Regis and the State of New York from 1816 to 1845 that Eleazer Williams was not one of their trustees, which is possibly the reason the state used the word "deputy" in the treaty. It would be interesting to see from the tribe's own histories if the other men were really representatives or not. This small group does not seem to be adequate to represent the wishes of the Indian population of the State of New York, especially when the tribes had verbally and in letters shown no real interest in leaving. The few individuals of the nations who chose to go went on their own accord. The land ceded to the New York Indians led to disputes among the tribes. The Winnebago and Menominee thought they had only allowed the use of the land to the New York tribes, not that they had given up title to it entirely. In order to solve the problem, the United States government entered into several compromise treaties with the tribes involved between 1831 and 1838.

It is at this point in the story that many written works discuss Eleazer Williams's plan to set up his colony of Indians. Many of the records, writings and personal accounts of Eleazer reside in Wisconsin, and the peculiar story of him emerges.

In *Leading Events of Wisconsin History: The Story of the State* (1898), Henry Eduard Legler writes, "Long before, it had been planned to convert Wisconsin into a great Indian territory. As early as 1822 a contingent of Brothertown and Oneida Indians were transported hither from New York. There was a plan to found a great Indian empire, but the man who conceived it, Eleazer Williams, was an erratic individual and his scheme came to naught."

In *The Story of Wisconsin* (1899), Reuben Gold Thwaites writes, "He was born an intriguer, and fell into this emigration scheme with enthusiasm. His original aim was said to be the establishment of an Indian government in the Green Bay country, of which he should be dictator. Thereafter, we find him the most prominent character in the migration of the New York Indians."

In the government report called "Report of the Wisconsin Territory, 1831," a description of the New York Indians and Eleazer Williams is as follows:

I will now proceed to exhibit to you the present location of the New York Indians, who have removed upon the land they claim from the Menominies, under their Treaty stipulations of 1821 and '22; and will then give you a particular description of the country provided for them, by the late Treaty, in accordance with my instructions. The whole number of Notaways or

Cradleboards were common a generation or two ago and are making a comeback.
Akwesasne Cultural Center.

New York Indians, men, woman, and children, who have emigrated to this country, and are now settled here, is according to their own estimate, five-hundred and ninety-eight, exclusive of about twenty Brothertown Indians who came here this fall. Of this number, the Oneidas claim 365: and the Stockbridges, including some Munces who have joined their tribe, claim 232; these, with the Rev. Eleazer Williams, a half breed of the St. Regis Tribe, compose the body of the New York Indians settled in the Menominie country, who have occupied no ordinary share of the attention and funds of the government for the last ten years.[74]

Only 598 people occupied this territory in 1831. Since this included children, not very many people must have originally left to create a population so small after ten years. If we do the math to get the 598 people, it looks like this: 365 Oneidas plus 232 Stockbridges and Munsees equals 597 people. This plus 1 person of the St. Regis, Eleazer Williams, equals 598. The report goes on to say:

Eleazer Williams, the representative of the Regis Indians, has his location on the west side of Fox river, at the Little Kaccalin, ten miles above Fort Howard. He is united by marriage, to a daughter of one of the French settlers at Green Bay; and when he happens to be in the country, which is very seldom, he resides principally at a house of his father-in-law, and rents his house at Little Kaccalin to a tenant. In this situation it is at present. There has been no settlement made here by any of the New York Tribes, claiming under purchase made from the Menominies, other than those I have mentioned.

It is clear by the report that very few people from the New York tribes had any interest in going to Wisconsin, and very few actually went. Eleazer, as it states, was seldom there during this period. One reason is he was still traveling between there and New York State. The other reason is he was negotiating treaties elsewhere. Eleazer Williams's name can be found on several more treaties for which he acted as a representative of the St. Regis Indians in both Wisconsin and New York. Through grants and legislative acts, it is apparent that he was paid well for his services in assisting in the removal of the New York tribes.

THE MINDSET AND STRATEGY OF THE UNITED STATES

I believe that George Washington wished to treat the Indians on a government-to-government basis without interference from the states and private parties and the problems that were already beginning in his administration are the ultimate reason for the Nonintercourse Act. He realized what would happen if there were no regulations to follow. Unfortunately, the reigning parties after him saw things differently. In a report entitled "Emigration of the Indians West of the Mississippi," we can see the government, by this point, did not care if anyone of tribal authority signed the treaties, as long as someone signed.[75]

In an excerpt from a lengthy letter, contained in this report, from Thomas L. McKenney to James Barbour, secretary of war, dated December 27, 1826, we can see this is evident, and the practice of using anyone who would sign, chief or not, was the new way of doing things.[76] Although in this particular case McKenney is referring to the Cherokee, Chickasaw, Choctaws and Creeks, he does mention the eastern tribes in general and gives a good idea of the mindset in the "west of the Mississippi" removal plan. If we add the Seminoles, we have what the U.S. government referred to as the "Five Civilized Tribes." Why were they deemed civilized? Because they took up the plow, as they say, and also had become involved in forms of manufacturing.

This letter admits to the mode of treating with the tribes involved—getting any willing signers—and how it was no longer working because the Indians had caught on. McKenney writes:

The exception on the part of those Indians to this mode arise out of preconceived prejudices, and out of the circumstances of making the proposition direct to the enlightened among them, who, if they happen not to be chiefs, have an influence over those who are, which they exert, and which has been, and in my opinion will continue to be, effectual in defeating such propositions made in this form in the future. Those prejudices, it must be conceded, are natural. They arise out of a view of the past. Those enlightened half-breeds, from whom the opposition to emigrate generally comes, read in the history of the past the effect of this mode of acquiring lands. They see this entire country of the east has been swept from their brethren who once inhabited there; and that, as the chiefs in the middle and northern states have listened to proposals to treat with them, they also have disappeared, until only a remnant of their once mighty race is left… Those intelligent and lettered Indians exert an influence over the headmen, and over as many of the body of their people as they can reach, which has resulted, as we have seen, in their refusal to acquiesce in the terms proposed to them. The obstacles to their removal, are, in my opinion, in great part, those which arise out of the mode of approaching them.

Thomas L. McKenney explains in the same letter that this method was also determined to be the best by John McKee, who had written his own letter to the War Department expressing the same view to "overcome this obstacle." McKenney shares McKee's thoughts:

Assemble at some suitable and central place the enlightened and influential half-breeds of those tribes, for the purpose of explaining to them, by persons to be appointed for that object, and who should carry with them, not only the full instructions of the government, and its pledges, but also an influence arising out of a known friendship to the Indians, what are the real views of the Government in relation to them, and especially those which have been indicated in the plans that have been proposed for their location on lands west of the Mississippi. It is not my opinion that all those who might assemble at such a council would return from it with sentiments and purposes favorable to a removal themselves, but I do believe the most of them would perceive that, if their own interests would be promoted by remaining on the lands they now occupy, and suitable and liberal portions of them should be given individually, the interests of the great body of their people would be promoted by emigration.

St. Regis Mohawk School, Emma White's class, 1953. *Akwesasne Cultural Center.*

The other obstacle to overcome was the objections of the teachers in schools that operated among the Indians in their "aim to enlighten and instruct them and to introduce them into the benefits and blessings of the civilized and Christian state." McKenney felt they would be favorable to the removal and help in carrying out the plan if they were reimbursed for the investment they had already made in buildings, supplies and other provisions used for schools. If that were done, he states, "There are reasons therefore, to authorize the belief that the teachers will co-operate in the measure, should an appropriation be made to defray the expense of such removal and settlement." Most often, the teachers of these schools were of one religion or another. It is admitted in this document that the government had no idea what this territory was like, only that it was north of the Arkansas River and west of the state of Missouri (what is today known as Kansas) and that no examination of it had been made as to the quality of the soil or environment. They calculated they could remove them at about "$30 a head."

It is true that those who were adopted into the various tribes were then considered and treated the same as if they were native to the tribe. What about the government's view? In reading the above, it seems clear the government purposely targeted "half-breeds" to do their dirty dealings. In the government's thought process, if you can appeal to their non-native side,

promise them a perk of some kind if they sell the rest on removal, then your job is half done, so to speak. I can see no other way to interpret it. The report clearly says, "The intentions and objects of the government have not been made known, except in a general way, to any of the tribes, although the intelligent among them appear in some instance to understand them, so far at least as these relate to removal."

Although some of the members of the tribes did not see at that time what the agenda was, the above report lays out the plan. Many of the Indians the government dealt with that it called half-breeds were men who had been captured by Indians after they had already been exposed to "civilization" or those of mixed marriages. This is not meant to reflect on the tribes but on what the government may have been really thinking. For example, in the government's mind, if it dealt with someone who was not totally native but was treated as one of the tribe's own, did the government think that this would give it an in—that these people were more easily manipulated and predisposed to assimilation? In retrospect, many who had been chosen by the government to perform important duties in negotiations were of mixed blood or adopted.

Unknowingly, those chosen may have been purposely picked by the government because they *were* of mixed blood or because they *were* totally white and adopted by the tribe. If you follow the plan above, dealing with only the "half-breeds" (using the government's term), allowing them to stay if they could convince the rest of the more traditional members of the tribe to remove, then you would be left with only a very few who were not of full blood living on the east side of the Mississippi River. Residents on individual parcels would meld into the population until the bloodline disappeared through assimilation. If the point of this plan was to separate those who had "read the history of the past" and become more aware from those who had not and move the former out west, it would make for a more easily controlled population. It is therefore possible that many of these men were picked for a reason from day one as negotiators, Indian agents or interpreters—not just because of their great language skills but because they were going to be unwittingly used to help remove those who would not fit into the plan.

Then there were those who did fit into the plan and, by their actions, appeared to be knowingly and willingly participating, like Eleazer Williams, as is seen by the document below.

Journal of the executive proceedings of the Senate of the United States of America, 1815–1829

Wednesday, March 26, 1828.
The following message was received from the President of the United
States, by Mr. John Adams, his Secretary:
 To the Senate of the United States:
 Washington, 7th March, 1828.
 The resolution of the Senate, of the 28th ultimo, requesting me to cause
to be laid before the Senate all papers which might be in the Department of
War, relating to the treaty concluded at the Butte des Morts, on Fox River,
between Lewis Cass and Thomas L. McKenney, Commissioners on the
part of the United States, and the Chippewa, Menomonie, and Winnebago
tribes of Indians, having been referred to the Secretary of War, the report of
that officer thereon is herewith enclosed. The papers therein referred to, were
all transmitted to the Senate with the treaty. Before that event, however, a
petition and several other papers had been addressed directly to me, on behalf
of certain Indians, originally, and in part still residing within the State of
New York, objecting to the ratification of the treaty, as affecting injuriously
their rights and interests. The treaty was, itself, withheld from the Senate,
until it was understood at the War Department, and by me, that by the
consent of the persons representing the New York Indians, their objections
were withdrawn; as, by one of them, the Reverend Eleazer Williams, I
was personally assured. Those papers, however, addressed directly to me,
and which have not been Upon the files of the War Department, are now
transmitted to the Senate.
<div align="right">

John Quincy Adams.
The message and the documents were read.
Ordered, That they be referred to the Committee on Indian Affairs.
</div>

In "Report of the Wisconsin Territory, 1831," you'll recall that it stated, "Eleazer Williams, the representative of the Regis Indians, has his location on the west side of Fox river, at the Little Kaccalin, ten miles above Fort Howard." It seems likely that Eleazer was the only person who came from St. Regis in 1822 to settle on the land at Green Bay. During this time, he also began the process of requesting a grant of land, titled to himself, for all his help.

Eleazer had his hand in several treaties, as government documents show, and he finally secured his own parcel under the 1838 treaty. It is evident by the Adams document that he acknowledged his affiliation with the Indians, as being one of them. His paternal story would flip back and forth, between this and the heir to the throne of France story, subject to what his goal was at the time.[77]

THE MOTIVES BEHIND THE 1838 TREATY

B y this point in time, the Ogden Land Company held the preemptive rights to the remainder of the Seneca Indian territory in Western New York, and the company wanted the land, the most prized piece being that of Buffalo Creek. David A. Ogden of the company had purchased the preemptive rights to over 197,000 acres in 1810 from the Holland Land Company. Preemptive rights meant that the Ogden Land Company had the first right to purchase it. However, in the company's mind, it already owned the land and considered the members of the tribes to be more like lease holders. However, much to the company's dismay, the Senecas had no desire to move.

In 1828, Andrew Jackson became president and was the driving force behind the policy of Indian removal. After gold was found in Georgia, in Cherokee territory, Indian removal became the goal of his administration. The Cherokee sued in a case that went all the way to the Supreme Court. The case was called *Cherokee Nation v. Georgia* (1831). In Chief Justice John Marshall's ruling of the case, he stated that "Indian tribes were 'a distinct political society, separated from others, capable of managing [their] own affairs and governing [themselves]' and the government had no authority to remove them." Jackson's reply to the ruling was, "John Marshall has made his decision; now let him enforce it."

In the hopes that the Senecas would eventually remove if pressured enough, the Ogden company focused its attention on the land still held by the other tribes of New York on which it had no preemptive rights. The

company gladly supported Eleazer Williams moving the Oneidas (the Christian part of them) to the Green Bay territory and supported the United States government in its removal plans. It also appears that, later, Eleazer was more than willing to help the Ogden Land Company negotiate treaties that would release the land in Wisconsin, and the rest in New York in exchange for lands in Kansas, land that was said to "not be fit for white men." Thus the treaty of 1838, although primarily directed at the Senecas, covered all the tribes of the state. The thinking on the Ogden company's part was if the other tribes left, the Senecas would surely follow.

As stated in earlier chapters, it is my opinion that Eleazer Williams was actively involved in this process for the exchange of lands and the removal of the Indians. The following government document supports this opinion.

Journal of the executive proceedings of the Senate of the United States of America, 1837–1841
MONDAY, December 11, 1837.
On motion by Mr. White,
Ordered, That the Secretary of the Senate be authorized to deliver to the Secretary of War the following papers now on the executive files of the Senate, to wit:

The original articles of agreement signed by Jonathan Keller and others on the part of the Miami Indians, at the forks of the Wabash, on the 31st of July, 1837, which accompanied the treaty with the Miami tribe of Indians made at the same place on the 23d October, 1834, and transmitted to the Senate with the message of the 4th of October, 1837; and the original power of attorney given by the Saint Regis Indians, of New York, to Eleazer Williams, on the 3d of August, 1836, which accompanied the treaty with the Oneida, Tuscarora, and Saint Regis Indians, concluded at Duck Creek, Wisconsin Territory, on 16th September, 1836; and the supplementary articles concluded at the same place, on 9th of December, 1836, which were transmitted to the Senate with the message of the 25th January, 1837. It is unknown where the Power of Attorney mentioned is kept today, or by whose authority it was given, if it was by someone at St. Regis or someone from the government.

The original removal treaty was held at Buffalo Creek on January 15, 1838. It was to give up the land in New York State and to trade land that was allotted to the Indians in Green Bay, land in what is today known as Kansas. The description of the Kansas lands from the treaty is as follows:

A map of Kansas, Texas, Indian Territory. The bold outline (added) in bottom right of map shows land set aside for the "New York Indians." *U.S. Government Printing Office, 1885. David Rumsey Map Collection.*

The following tract of country, situated directly west of the State of Missouri, as a permanent home for all the New York Indians, now residing in the State of New York, or in Wisconsin, or elsewhere in the United States, who have no permanent homes, which said country is described as follows, to wit: Beginning on the west line of the State of Missouri, at the northeast corner of the Cherokee tract, and running thence north along the west line of the State of Missouri twenty-seven miles to the southerly line of the Miami lands; thence west so far as shall be necessary, by running a line at right angles, and parallel to the west line aforesaid, to the Osage lands, and thence easterly along the Osage and Cherokee lands to the place of beginning to include one million eight hundred and twenty-four thousand acres of land, being three hundred and twenty acres for each soul of said Indians as their numbers are at present computed.

As noted before, Eleazer Williams was the only person from St. Regis to sign the treaty in January 1838. In the treaty, it clearly states that the land he was to secure at Green Bay was not for the tribe but for him alone. The St. Regis, if they were to move, were now going to be sent to Kansas, Eleazer having signed away any of the tribe's right to any land at Green Bay. As stated in an earlier article, remember the $5,000 figure, as it will come up again years later. Per the Treaty of January 1838:

Special Provisions for the St. Regis.
Article 9.
It is agreed with the American party of the St. Regis Indians, that the United States will pay to the said tribe, on their removal west, or at such time as the President shall appoint, the sum of five thousand dollars, as a remuneration for monies laid out by the said tribe, and for services rendered by their chiefs and agents in securing the title to the Green Bay lands, and in removal to the same, the same to be apportioned out to the several claimants by the chiefs of the said party and a United States' Commissioner, as may be deemed by them equitable and just. It is further agreed, that the following reservation of land shall be made to the Rev. Eleazor Williams, of said tribe, which he claims in his own right, and in that of his wife, which he is to hold in fee simple, by patent from the President, with full power and authority to sell and dispose of the same, [emphasis added] *to wit: beginning at a point in the west bank of Fox River thirteen chains above the old milldam at the rapids of the Little Kockalin; thence north fifty-two degrees and thirty minutes west, two hundred and forty chains; thence north thirty-seven degrees and thirty minutes east, two hundred chains, thence south fifty-two degrees and thirty minutes east, two hundred and forty chains to the bank of Fox river; thence up along the bank of Fox river to the place of beginning.*

The treaty, if looked at today in a book or online, is not the original treaty. You will, in fact, see more signatures than were made on January 15, especially for the Seneca tribe. As a government inquiry to the validity of the treaty the following year will show, only thirty-one of the eighty to ninety Seneca chiefs signed the treaty on January 15, 1838; the other signatures were gathered later under suspicious means. On this date, only two from the Oneida nation of New York signed to give up rights to their New York territory and four from the Oneidas at Green Bay to give up their rights to the remainder of the unoccupied land in Wisconsin. There were also three other Oneida signatures; they were from those who resided on Seneca reservations, which in itself should have raised questions on their authority to convey Oneida territory. As to the other signatures, there were ten from Tuscaroras; only two warriors, not chiefs, from the Onondaga; four from Cayugas; and thirteen additional Cayugas who were also warriors, not chiefs. Since only Eleazer Williams had signed it on behalf of the St. Regis, more signatures were still needed. This was amended to the treaty at the council house of the St. Regis on February

Akwesasne craft people made their living selling their creations, circa 1925. *Left to right:* Anna "Kaia'tentas" Sunday, Larry "Kahakeron" Lazore and Marion "Oronhio:kon" Cook Lazore. *Akwesasne Cultural Center.*

13, 1838 (and again in October). It is here that it was expressly said the St. Regis were not compelled to remove.

The treaty would be amended again by a resolution of the Senate of the United States on June 11, 1838, in regard to the Oneidas, Onondagas, Senecas, Tuscaroras and St. Regis. During this resolution, a great deal of the text of the original treaty held on January 15, 1838, was stricken after the fact, and new wording was inserted. The tribes were approached again in August, September and October 1838 with the treaty containing the new wording. It is at this point that many refused to sign, and the treaty as a whole was disputed by the Six Nations of New York as a fraud. Also, in the wording of the treaty itself, many of the signatories had been bribed. It had been agreed upon by the government and certain select Indians prior to the treaty who was going to be paid and how much in order to obtain their signatures.

Despite the objections of the majority of the people of the tribes, the government investigation and letters of complaint from the public, the

revised treaty was eventually ratified in 1840. The problems that arose from this treaty lead to the compromise treaty of 1842. The following chapter will be a comparison of the old text, which is among the records of the *Journal of the Executive Proceedings of the Senate of the United States*, with the text you see today contained in the version of the ratified treaty of 1838, and we will also see who was paid what. If you would like to review the ratified treaty and print it out, you can find it by going to http://digital.library.okstate.edu/kappler/Vol2/treaties/new0502.htm.

TREATY CHANGES AND BRIBES

The objective of the treaty of 1838 was to acquire what land had been "reserved" to the Senecas under the Big Tree Treaty of 1797 that they still retained after the treaty of 1826. The Senecas still retained title to several thousand acres of land west of the Genesee River that the Ogden Land Company was willing to do anything to get it, even through illegal means—in other words, threats and bribery. The company needed the Seneca signatures on the treaty, not only because it wanted their land but also because the Senecas held the majority of the people of the Six Nations.

According to the treaty of 1838, a census was conducted in 1837 that resulted in the following population count. Residing on the Seneca reservations in New York were 2,309 Senecas, 194 Onondagas and 130 Cayugas, totaling 2,633 people. Of the other tribes residing on their own lands in New York were 620 Oneidas, 300 Onondagas, 350 St. Regis and 273 Tuscaroras. Also included in the census were 600 Oneidas at Green Bay, 360 Brothertowns, 217 Stockbridges and 132 Munsees.

Although under the rules of Indian nations' governments all the chiefs would need to sign, in the eyes of the United States government, the treaty would be valid if the majority of the Indians agreed, similar to the United States' form of government. Therefore, it was important for the United States to get the consent of the Senecas by whatever means possible.

Journal of the executive proceedings of the Senate of the United States of America, 1837–1841

MONDAY, March 5, 1838.

Mr. Clay, of Kentucky, presented the affidavits of John Bocks, John Tall, Jack Wheelbarrow, John Seneca, Big Kettle, George Lindsay, William Cast, Jacob Jimeson, John Gordon, and Long John, representing themselves to be chief, of the Seneca tribe of Indians, and stating that an instrument lately executed on the Buffalo Reservation, in the State of New York, purporting to be a treaty between the United States and the Six Nations for the sale of their several reservations in the State of New York, and for their removal therefrom, had been obtained from the said Indians through false pretenses.

Almost as soon as the treaty of January 15, 1838, was signed, protests arose from the Senecas. Only thirty-one of the eighty to ninety chiefs had signed the treaty. It was not valid under their government without the signatures of all the chiefs. The federal government's investigation took place the following year and was printed in the *Journal of the Executive Proceedings of the Senate of the United States of America, 1837–1841, THURSDAY, February 28, 1839.* It states the government's knowledge of this: "It appears from the testimony that the treaty making power with this tribe is vested in and exercised by the chiefs."

It also appears that of the thirty-one signatures taken, they were not all taken at the same time, nor were all of them taken during council. In a report by Mr. Sevier from the Committee on Indian Affairs during the committee's investigation into Ransom H. Gillet (the commissioner on the part of the United States), an excerpt from the same proceedings concerning his actions in conducting the treaty recites:

At page sixteen of the same document, in the letter aforesaid, the commissioner, after describing the course he had taken to obtain signatures of assent to the amended treaty by obtaining leases for them, &c., he states: "I presented the manuscript copy of the amended treaty, to which I had attached a written assent. I informed the council that those who chose to do so could sign it, and those who, from fear or other cause, preferred signing at my room, in presence of myself, the superintendent from Massachusetts, the agent, and such other persons as might be present, might do so. I then received sixteen signatures, and subsequently, at my room, in presence of General Dearborn, thirteen, and two other signatures at the rooms of chiefs who were too unwell to attend council, making in all thirty-one chiefs. These were all by persons who understood the subject, and were freely and voluntarily given."

Only one-third of the Seneca chiefs had signed the treaty. Of those thirty-one chiefs who signed, only sixteen had signed during council; the other fifteen signatures had been taken privately where the others wouldn't see them do it. Because of the protest of the majority of the Seneca chiefs, thus causing problems in getting the treaty ratified, Schedule D of the original treaty was stricken during the treaty revision in June 1838. Schedule D was the bribe that was to be paid to certain chiefs who had signed the treaty. During this treaty, where a tribe as a whole was to receive a meager sum of money to *help* in their removal, some of the chiefs who were bribed were to receive $500 to $2,000 apiece. If you look at the revised 1838 treaty, which was ratified in 1840, you will not see a Schedule D. From the *Journal of the Executive Proceedings of the Senate of the United States of America, 1837–1841 Monday, June 11, 1838*, we can see the stricken Schedule D:

Strike out Schedule D, in the following words:

Schedule D. The United States will pay to the persons named below the sums mentioned for them, as remuneration for their services in procuring the Green Bay country, and for services as delegates in exploring the western country, and for losses sustained in consequence thereof, and for other services, to wit: To George Jameson, two thousand dollars. To Thompson S. Harris, twelve hundred dollars. To Nathaniel T. Strong, one thousand dollars. To Seneca White, one thousand dollars. To Marus B. Pierce, one thousand dollars. To William Johnson, one thousand dollars. To James Young, one thousand dollars. To William King, five hundred dollars.

The above-mentioned sums to be paid the persons named on their settling at their new homes at the West.

To William Patterson, Israel Jameson, Little Johnson, White Seneca, Silver Smith, Baptiste Pawlis, Jonathan, Jourdan, Martin Daney, John Anthony, Honyost Smith, Henry Jourdan, James Cusick, and James Young, each the sum of two hundred dollars, to be paid when an appropriation is made to the persons mentioned, first deducting the following sums, which have been already advanced to them by J.F. Schermerhorn, to wit: William Patterson, one hundred and fifty dollars; Israel Jameson, fifty dollars; Little Johnson, sixty dollars; White Seneca, one hundred dollars; James Young, one hundred dollars; and Silver Smith, fifty dollars, which respective sums have been heretofore advanced by said Schermerhorn and are to be paid to him, they having been with him on the exploring expedition at the West.

The above was agreed to as a part of the treaty before the same was finally executed.

R.H. Gillet, Commissioner.

By these words, one can see that this payment was agreed to *before* the treaty was signed. In the end, under the amended treaty that was ratified in 1840, under Schedules B and C, James Cusick's (Tuscarora) fee was reduced to $125 and William King and Silver Smith (Onondaga or Cayugas residing with the Senecas) got increases, William King to $1,500 and Silver Smith to $1,000. The rest of the men were stricken out. Added to the list under Schedules B and C are five additional Tuscaroras who would be paid between $50 and $175. Four other Onondagas or Cayugas residing with the Senecas were paid between $300 and $700 apiece.

Under Article 2 of the treaty, the rights for the tribes to convey their land were changed from:

With full power and authority to divide the same among the members of the different tribes in severally, with power and such laws and regulations as may be adopted by the respective tribes authority to sell among each other and their Indian brethren of the Indian Territory, under themselves, or by a general council of the New York Indians.

To the new wording:

With full power and authority in the said Indians to divide said lands among the different tribes, nations, or bands of New York Indians, or among the members of said tribes, nations, or bands, in severally, with the right to sell and convey to and from each other, under such laws and regulations as may be adopted by the respective tribes, acting by themselves, or by a general council of the said New York Indians, acting for all the tribes collectively.

This may seem like a minor change, but it isn't. The first version gives the power to each respective tribe. The second version is acting for all tribes as one group. It appears to me that the first version was closer to maintaining each tribe's individuality. However, that would defeat the purpose of the treaty. One of the main objectives was to break down each tribe's cultural uniqueness by taking away their individualism. Hence the words were changed to "by a general council…acting for all tribes collectively" to fit the government's new lingo of "New York Indians." I believe the government

knew that this would cause turf problems; in fact, I believe it was counting on just that. One of the easiest ways to break down the Indians' strength was to get them to fight among themselves.

The original Article 3 of the treaty of January 1838 that was signed was quite lengthy. Under the original Article 3, the United States promised to supply the tribes with provisions for one year after their arrival in Kansas. Each chief who was considered competent enough to act as a subagent was to "be paid at the rate of five hundred dollars for every party of one hundred persons so by him removed." Also, a physician was to accompany each party of emigrants if they wanted one. The government agreed to build, "for the use of the respective nations, as many council-houses, churches, school-houses, saw-mills, grist-mills and blacksmith shops, not to exceed one for each nation" and to "pay suitable teachers, millers, and blacksmiths, and furnish the necessary coal, iron, steel, and blacksmiths' tools for ten years, and as much longer as the President shall deem proper."

All of these provisions in Article 3 were stricken during the revisions in June 1838, and Article 3 was changed to read:

> *It is further agreed that such of the tribes of the New York Indians as do not accept and agree to remove to the country set apart for their new homes within five years, or such other time as the President may, from time to time, appoint, shall forfeit all interest in the lands so set apart, to the United States.*

This is quite a large difference from what was promised in the original treaty, the treaty the nations saw and signed. There is an extensive number of edits when comparing the original treaty signed in January 1838 to the revised one in June of that year, which is the one that was ratified in 1840. Basically, the government promised the Indians everything to get any one of the chiefs to sign. Six months later, the treaty was revised without the chiefs' knowledge and consent, and they were left to fend for themselves, the government knowing most would not survive the trip. Although the "Trail of Tears" era is most associated with the Cherokee and the rest of the Five Civilized Tribes, it affected all tribes that happened to be on the wrong side of the Mississippi River. Despite the fact that the fraudulent treaty was not ratified by Congress until 1840, it didn't matter to the government because the removal plan had passed by a majority of the Senate.

The Ohio Repository, May 17, 1838, pg. 2
TWENTY-FIFTH CONGRESS, Second Session—Territorial Government—On Tuesday last, a bill for the establishment of a Territorial Government over the Indians who have been sent west of the Mississippi, passed the Senate of the United States, by a vote of 38 to 6.

The bill in question was S.75, presented in December 1837 to the Twenty-fifth Congress, second session, and is as follows:

Committee: Committee on Indian Affairs
December 20, 1837 ~ December 28, 1837
Agreeably to notice, Mr. Tipton asked and obtained leave to bring in the following bill; which was read twice, and referred to the Committee on Indian Affairs, Reported without amendment. A Bill To provide for the security and protection of the emigrant and other Indians west of the States of Missouri and Arkansas.

<center>***</center>

Journal of the Senate of the United States of America, 1789–1873 (Pg 383)
MONDAY, April 29, 1838.

The Senate resumed, as in Committee of the Whole, the consideration of the bill (S.75) to provide for the security and protection of the emigrant and other indians west of the States of Missouri and Arkansas.
On motion by Mr. King,
To amend the bill by inserting, section 1, line 13, after the word "same," "and that all that portion of country belonging to the United States to which the Indian title has not been extinguished, which lies east of the Rocky mountains and north of the Missouri river, and State of Missouri, and west of the Mississippi river, shall constitute an Indian, Territory, to be denominated—Territory, which shall be, and the, same is hereby, reserved for the use of the various Indian tribes who have, or may have, a right to the same,"
It was determined in the negative,
Yeas,...11,
Nays,...33.
On motion by Mr. Sevier,
The yeas and nays being desired by one-fifth of the Senators present,
Those who voted in the affirmative are,

Messrs. Calhoun, Clay, of Alabama, Fulton, King, Merrick, Mouton, Nicholas, Preston, Roane, Sevier, Spence.

Those who voted in the negative are,

Messrs. Allen, Benton, Brown, Clay, of Kentucky, Clayton, Crittenden, Cuthbert, Davis, Grundy, Hubbard, Knight, Linn, Lumpkin, Lyon, Morris, Niles, Norvell, Pierce, Rives, Robbins, Robinson, Ruggles, Smith, of Connecticut, Smith, of Indiana, Southard, Swift, Tallmadge, Tipton, Wall, White, Williams, Wright, Young.

The bill having been amended, was reported to the Senate, and the amendments were concurred in.

On the question, "Shall this bill be engrossed, and read a third time?" It was determined in the affirmative,

Yeas,…38,

Nays,…6.

On motion by Mr. Norvell,

The yeas and nays being desired by one-fifth of the Senators present, Those who voted in the affirmative are,

Messrs. Clay, of Alabama, Clay, of Kentucky, Clayton, Crittenden, Cuthbert, Davis, Fulton, Grundy, Hubbard, King, Knight, Linn, Lumpkin, Lyon, Merrick, Morris, Mouton, Nicholas, Pierce, Preston, Rives, Roane, Robbins, Robinson, Sevier, Smith, of Connecticut, Smith, of Indiana, Southard, Spence, Swift, Tallmadge, Tipton, Trotter, Wall, White, Williams, Wright, Young.

Those who voted in the negative are,

Messrs. Allen, Benton, Brown, Calhoun, Niles, Norvell.

So it was

Ordered, That this bill be engrossed, and read a third time.

On motion,

The Senate adjourned.

<p style="text-align:center">***</p>

Journal of the Senate of the United States of America, 1789–1873 (PG 385)

WEDNESDAY, May 2, 1838.

The bill (S.75) to provide for the security and protection of the emigrant and other Indians west of the States of Missouri and Arkansas, having been reported by the committee correctly engrossed, was read a third time.

On motion by Mr. Linn,

The bill was amended by unanimous consent.
On the question, Shall this bill pass?
It was determined in the affirmative,
Yeas,…39,
Nays,…6.
On motion by Mr. Prentiss,
The yeas and nays being desired one-fifth of the Senators present,
Those who voted in the affirmative are, 25
Messrs. Buchanan, Clay, of Alabama, Clay, of Kentucky, Clayton, Crittenden, Cuthbert, Davis, Fulton, Grundy, Hubbard, King, Knight, Linn, Lumpkin, Lyon, Merrick, Morris, Nicholas, Pierce, Prentiss, Preston, Rives, Roane, Robbins, Robinson, Ruggles, Smith, of Connecticut, Smith, of Indiana, Southard, Spence, Swift, Tallmadge, Tipton, Trotter, Wall, White, Williams, Wright, Young.
Those who voted in the negative are,
Messrs. Allen, Benton, Brown, Calhoun, Niles, Norvell.
So it was
Resolved, That this bill pass, and that the title thereof be as aforesaid.
Ordered, That the Secretary request the concurrence of the House of Representatives therein.

Similar to the way things are done today, they voted and then voted again until the bill passed. The push to remove the tribes had begun.

14

THE PROVISIONS FOR THE NEW YORK INDIANS

The majority of the Senecas had protested the validity of the treaty of 1838 soon after it was signed based on the limited number of chiefs who had signed it. By the treaty itself, it was clear that payoffs had been prearranged. Under the treaty, the Senecas were to give up the remainder of their land, which was 49,920 acres in Buffalo Creek, 29,680 acres in Cattaraugus, 39,469 acres in Allegany and 12,800 acres in Tonawanda, all for $202,000. (It should be noted there is no mention of the Senecas collectively giving up the Oil Spring Reserve.) Due to the Senecas' constant protests and the protest of the Society of Friends, the treaty was not honored by the Senecas and led to investigations by the United States in 1839. Following is an excerpt of a letter from Martin Van Buren to the United States Senate:

Tuesday, January 14, 1840.

M. Van Buren
To the Senate of the United States:
...I again submit to you the amended treaty of June 11, 1838, with the New York Indians. It is accompanied by minutes of the proceedings of a council held with them at Cattaraugus on the 13 and 14 days of August, 1839, at which were present, on the part of the United States the Secretary of War, and on the part of the State of Massachusetts General H.A.S. Dearborn, its commissioner, by various documentary testimony, and by a

memorial presented on behalf of the several committees on Indian concerns appointed by the four yearly meetings of Friends of Genesee, New York, Philadelphia, and Baltimore. In the latter document the memorialists not only insist upon the irregularity and illegality of the negotiation, but urge a variety of considerations which appear to them to be very conclusive against the policy of the removal itself…

This measure is further objected to on the ground of improper inducements held out to the assenting chiefs by the agents of the proprietors of the lands, which, it is insisted, ought to invalidate the treaty, if even the requirement that the assent of the chiefs should be given in council was dispensed with. Documentary evidence upon this subject was laid before you at the last session, and is again communicated with additional evidence upon the same point. The charge appears by the proceedings of the Senate to have been investigated by your committee, but no conclusion upon the subject formed other than that which is contained in the extract from the report of the committee I have referred to, and which asserts that at least in one instance the charge of bribery has been clearly made out. That improper means have been employed to obtain the assent of the Seneca chiefs there is every reason to believe, and I have not been able to satisfy myself that I can, consistently with the resolution of the Senate of the 2ᵈ of March, 1839, cause the treaty to be carried into effect in respect to the Seneca tribe.[78]

The protest by the Senecas and the public pressure ultimately led to the Compromise Treaty of 1842.[79] In this treaty with the Senecas, a portion of the Senecas agreed to give up the remaining land in Buffalo Creek and the Tonawanda Reservation in order to keep the Cattaraugus and Allegany land. Not only had the Senecas from Allegany and Cattaraugus, who had been present at this treaty, sign away Buffalo Creek, which was sacred, but they also had given up the land of the Senecas at Tonawanda in order to keep their own. There were no chiefs from the Tonawanda present at the treaty of 1842.[80] They had been sold out. It was these actions that led to the "political" split of the Senecas.

The Tonawanda Band of Senecas would eventually have their day in court (a story in itself). In 1857, the Tonawanda Senecas entered into another treaty with the United States and used the money allotted for their removal to buy as much of their reservation as they could, which they technically already owned.[81] Although the Tonawanda Reservation was reduced in size from 12,800 acres to 7,547 acres, it was undisputedly theirs.[82] A summary of the provisions for the other tribes, in exchange for the lands in New York State, were as follows:

Article 9. Special provisions for the St. Regis. This is the land that was allotted to Eleazer Williams and his wife in fee simple, plus $5,000 for the removal of any of the St. Regis if they chose to remove. Eleazer Williams would later file a claim with the United States for the $5,000, but for his benefit alone and not for the benefit of the St. Regis.

Article 10. Special Provisions for the Senecas. The Seneca, had they agreed, were to receive for themselves and the Cayugas and Onondagas, residing among them, "the easterly part of the tract set apart for the New York Indians, and to extend so far west, as to include one half-section (three hundred and twenty acres) of land for each soul of the Seneca's, Cayuga's and Onondagas, residing among them." Plus $202,000 which was to be divided per "the sum of one hundred thousand dollars is to be invested by the President of the United States in safe stocks, for their use, the income of which is to be paid to them at their new homes, annually," and the balance of $102,000 for improvements.

Article 11. Special Provisions for the Cayugas. The Cayugas, on their removal to the west were to receive $2,000 invested in stocks, with the income paid annually, plus $2,500 to be disposed of by the chiefs as they saw fit.

Article 12. Special Provisions for the Onondagas Residing on the Seneca Reservations. The amount of $2,500 was to be given to the Onondagas, residing on the Seneca reservations, invested in stock with the income from which was to be paid annually; plus $2,000 to be disposed of by the chiefs as they saw fit.

Article 13. Special Provisions for the Oneidas Residing in the State of New York. The sum of $4,000 was to be paid to Baptista Powlis, and the chiefs of the first Christian party residing at Oneida, $2,000 to William Day and the chiefs of the Orchard party for "expenses incurred and services rendered in securing the Green Bay country, and the settlement of a portion thereof"; They were to remove as soon as they could make arrangements with the Governor of New York for the purchase of their lands they still held in the state.

Article 14. Special Provisions for the Tuscaroras. The land was to be appraised and the money received from its sale, placed in stock. The Tuscarora also ignored this treaty and never removed as a nation.

The United States was to use $400,000 to aid in the removal of the New York Indians and to help sustain them for one year. The Indians were to receive 1.824 million acres of land west of the state of Missouri (now Kansas) at 320 acres apiece. That was the plan anyway. In the end, however, only thirty-two people were found living there by the 1860s. The Kansas

lands were eventually sold, and allegedly, the money was allotted to the tribes in 1895 after a judgment in their favor, but was it? By newspaper articles published later, the matter seems to not have been completely settled.

The treaties of 1838 and 1842 and the issue of the lands in Kansas raise many unanswered questions. Although compensation was allegedly distributed to the tribes for the sale of the Kansas land, what happened to the money that was invested in safe stocks? Does stock still exist in the names of the tribes? If not, and the stock was sold, what happened to that money? The underlying results of the 1838 treaty will become even clearer as we head for Kansas.

As a side note, the title to the Oil Springs Reservation on Cuba Lake is an interesting one. The Senecas collectively owned Oil Springs. It was not a part of the treaties of 1838 or 1842 and, therefore, was still in title to the Seneca people after those treaties. It was controversy over the treaties that split the Senecas into the Tonawanda Band of Senecas and the Seneca Nation of Indians, which then took an elective form of government in 1848. However, I fail to see how that changed the status of Oil Springs being owned by the Seneca people collectively, including the Tonawandas. A portion of Oil Springs had been taken by illegal means in 1852, along with the Oil Creek Reservoir, in order to make Cuba Lake serve as a feeder for the Genesee Valley canal. The canal was abandoned in 1878. Cuba Lake was taken over by the New York State Conservation Commission in 1912, and lots were leased for cottages. In March 2005, the Seneca Nation won the land claim that they had begun in 1985 for the portion of the Oil Springs Reservation that had been taken. Shouldn't the rest of the Seneca people share equal title to it?

15

HEADING FOR KANSAS

Despite the refusal of the majority of the New York Indians to remove to the land west of the Mississippi, the land was set aside per the treaty of 1838, which had been ratified by Congress in 1840. The allotment was 1.824 million acres of land west of the state of Missouri in what is now known as Kansas. They were to receive 320 acres apiece based on a population of approximately 5,700 people from the New York tribes. Very few expressed any desire to leave. On June 30, 1843, the government budgeted $20,477.50 for the emigration of 250 souls from the Seneca, Cayugas and Onondaga nations.[83]

Here is an excerpt of James K. Polk's diary (U.S. president, 1845–49) from Thursday, September 11, 1845:

> *Held another talk with the Delegation of New York Indians, the Secretary of War and Commissioner of Indian Affairs being present. It was agreed to remove such of them as desired to emigrate, provided the number was 250 or greater. The President informed them that he would appoint Dr. Hogeboom, who resides near them, as the agent to conduct the emigrating party, if he would accept. One of the chiefs (Kusick) said he knew him, and they all expressed themselves satisfied with him.*[84]

On November 7, 1845, Dr. Abraham Hogeboom was appointed to assist in the removal west of 260 New York Indians and was to be furnished with $10,000 to defray expenses.

A council held at the Cattaraugus reservation on June 2, 1846, consisted of Senecas, Cayugas and Onondagas living with them, as well as Tuscaroras. An Indian commission was sent on behalf of the United States to get a final count of those who wished to remove. After holding enrollment open for two days, only 7 enrolled, and those 7 indicated that maybe only 5 more were considering it. The final count was 271 people, consisting 88 families. Having now the required number as set forth by the president, plans were made for the journey to Kansas.

When the time came to leave, 73 people had changed their minds. The party set out with 198 souls in May 1846. Of these people, only 191 arrived in the territory on June 15 and to their final destination on July 9, 1846. *The History of Livingston County, New York* gives an account of William Tall Chief, a Seneca born at Squawky Hill, who had made the journey.[85] According to Tall Chief, several of the party came down with ship fever on a Missouri steamboat, and 50 other people succumbed to the disease as well. After their arrival on their new land, 17 more arrived, bringing the total to 208. Of these people, 82 subsequently died.

Abraham Hogeboom died shortly afterward, and in 1848, his lawyers were still trying to collect the money that was owned for his assistance in the removal of the New York Indians. The bill, H.R. 232, was to pay a sum to his attorneys so they could settle his estate:

> *Such sum as he may deem just and equitable, for the moneys disbursed by said Hogeboom, while acting as emigrating agent in the removal of the New York Indians in eighteen hundred and forty-six, not exceeding five hundred and twelve dollars and fifty-six cents; and the Secretary of the Treasury is hereby directed to pay out of any moneys not otherwise appropriated, such sum as the Secretary of War shall certify to be justly due, as aforesaid; Provided, That the balance due to the United States from said Hogeboom at the time of his death shall have been previously paid into the treasury.*

This is a telling document. It implies that there is some question concerning the $10,000 the government was to give Hogeboom out of the $20,477.50. First, Hogeboom had not been paid for his services personally after two years. However, the treasury implied that $520.56 to reimburse him would not be paid until the balance due to the United States from Hogeboom was put back into the treasury. So what really happened with this money? It does not appear the government had $10,000 at its disposable to provide for the New York Indians to make the journey or set up a community once they got to Kansas.

The History of Bourbon County Kansas: To the Close of 1865 describes the opinion of the time by recounting, "Indians in the Eastern and Southern States, who were in the way of rapidly increasing population, had been given, and located on, large tracts of land in this worthless, sterile desert, totally unfit for the habitation of the white man, as it was believed, where they could quietly work out their own extinction."[86] But the white settlers came anyway.

The settlers immediately tried to force the New York Indians out. Of the original party, it was estimated (in 1860) that ninety-four returned to New York State. William Tall Chief had been one of those who attempted to return, the country having not agreed with him. He died of consumption along the way and was buried in Beaver, Ohio. According to Doty, there is no stone marking his grave.

The plan to move the Indian nations of New York to Kansas had failed. It is unknown at what point the rest left the New York reserve in Kansas, but by 1860, there were only thirty-two people left. Based on the 320 acres allotted to each, they occupied 10,240 acres of land and had settled on the Osage River near what is now known as Barnesville in the north part of Bourbon County.

In 1854, an act was put before Congress called an "Act to Organize the Territories of Nebraska and Kansas." It was only eight years after the New York Indians' arrival, and plans were already being made to take over the territory they had been given. In March 1856, bill S.172 was presented. It was called "A Bill to Authorize the People of the Territory of Kansas to Form a Constitution and State Government, Preparatory to Their Admission into the Union, When They Have the Requisite Population." On June 14, 1858, another bill came before the Senate, S.373, which was called "To Settle the Titles to Certain Lands Belonging to the Half-Breed Kansas Indians, in Kansas Territory." A report by the secretary of state to the Department of the Interior bears the same date. It was called "A Resolution of the Senate Relative to the Claim by the St. Regis Indians to the Land in Kansas." This story is not over yet.

16
THE TONAWANDA SENECAS KEEP THEIR TERRITORY

From 1838 to 1859, the Tonawanda Band of Senecas was in a battle of wills with the United States to retain its land in New York. In the government's eyes, since a few of the Seneca chiefs had signed the treaty of 1838, the treaty was binding. The Tonawandas opposed this new treaty and began their fight in Washington. The United States and the State of New York were to supervise the sale of their land. In exchange, they would be provided funds for their removal to Kansas. The plan was to remove all the tribes from New York within five years.

The Ogden Land Company, despite increased resistance from the Tonawandas, made arrangements to have the unimproved land surveyed and appraised. The land was divided into 195 lots that surrounded the Tonawanda Band of Senecas' village. Joseph Jones and Elias R. Cook did the survey in 1841. A copy of this map is on file at the Genesee County clerk's office in Batavia, New York (also on file in the Office of Indian Affairs in Washington, D.C.).[87]

In May 1842, with added pressure from the Ogden Land Company, the Senecas of Cattaraugus and Allegany were coerced into another treaty. "The Compromise Treaty of 1842" stated that the Ogden company could have the lands of the Buffalo Creek and Tonawanda Reservations. Also, within two years, the Indians who had occupied said land had to go to the reservations at Cattaraugus and Allegany. Again, the Tonawandas refused and pressed harder in their battle at Washington, D.C., but now with added help. Public outcry was sent in the form of letters and petitions to the

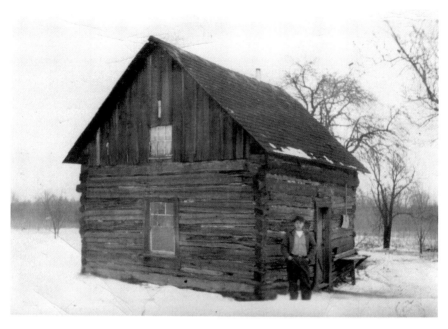

Arthur Smith (Seneca) standing beside Earl Parker's log house on the Tonawanda Reservation, 1947. Many of these, built in the early 1800s, are still standing. *Tonawanda Reservation Historical Society.*

Senate in Washington. The citizens of Genesee County, New York, and the Tonawandas' closest neighbors in the town of Alabama were outraged by the sale of the Tonawanda Senecas' lands. In 1842, Reuben Warren (son of Reverend Augustus Warren of Alabama and friend of Ely S. Parker) began a petition and collected signatures of thirty-four of his neighbors stating the Tonawanda Indians were moral, industrious and honest people. In part, the petition said, "The People of the State of New York do not desire their removal, and have no sympathy for their spoilers."

In April 1844, the appraisal of the unimproved land was completed and sent to Washington, D.C. On August 19, the land was to be put up for auction in Batavia. The new landowners immediately began settling on the Tonawanda Reservation. However, the appraisals for the improved land had not been completed. The Ogden Land Company had forced John Blacksmith, a Seneca Indian and sawmill owner, off his land on the Tonawanda Reservation. John Blacksmith sued. Since the Ogden company had never paid him for the improvements to his land, it held no right to it. This became an important litigation tool in court. This event was an important one because it bought some

Another important item the Senecas traded for was European beads. Seneca women used the beads to make jewelry, pouches, and other art forms, which they traded with Europeans.

Seneca women continued to make beadwork for tourists during the 1800s and early 1900s. The pouch shows how the art of beadwork became more sophisticated over time.

PURSE,
BLUE SILK AND BLACK VELVET
WITH FLOWER DESIGN

Above: Tonawanda Seneca beadwork for trade, pre-1900. *Holland Land Office Museum.*

Right: Believed to be Mary Smith Kennedy Billy Parker with daughters Molly Billy (right) and Sarea Billy (left), late 1800s. *Tonawanda Reservation Historical Society.*

time for the Tonawanda Senecas to continue to plead their case in Washington. The Blacksmith case got tied up in appeal after appeal. It was decided that the issue of ownership of the Tonawanda Seneca lands would be put on hold until the Blacksmith case was settled.

During several months of 1846, rallies were held in the court building in Batavia in Genesee County. Several influential men of the county and the general population attended the conventions. Louis Henry Morgan, author of *League of the Ho-de'-no-sau-nee*, was in attendance in a special court held in February and March 1846. Also present was John H. Martindale, a Batavia attorney, who would later represent the Tonawandas in court, with his partner William G. Bryan. Chief Jimmy Johnson, head of the Seneca Nation and successor of Red Jacket, delivered a speech.

The convention and the objections to the Senecas' removal filled column after column of the Batavia newspaper, the *Spirit of the Times*. According to this newspaper's report on February 24, it was "one of the largest assemblages, for a philanthropic purpose, ever assembled in the county. The Court Room was filled in every nook and corner, and the proceedings were of a very interesting character. We have barely room to state that in our next number we shall give a full account of the meeting, together with Memorial and Resolutions which were adopted." In 1851, John Martindale and William G. Bryan took on the Tonawanda Band of Senecas' land claim case.

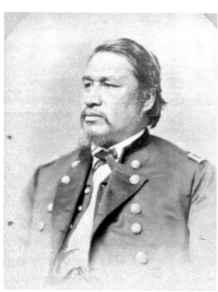

Portrait of Ely S. Parker. *Holland Land Office Museum.*

In 1857, the Blacksmith case made it to the Supreme Court. The Ogden company argued that the appraisal was not done because the Tonawanda Senecas would not allow them on the land to do it. In the court's view, since the appraisal had never been done and no money was paid to Blacksmith for improvements done on his land, the Ogden company held no title to it. The court decided that John Blacksmith was right, and he won his case. It was decided that the Senecas still had to abide by the treaties but that the Ogden Land Company had no right to remove them from the land; only the

federal government did. Bryan and Martindale began eviction proceedings against the squatters on the Tonawanda Reservation. Bryan began letters of introduction for himself, Martindale, Fredrick Follett and Ely S. Parker of the Tonawanda Reservation and then president of Indian Affairs to present their case as a delegation before President Buchanan and the secretary of the interior. After stating their case, the president, seeing no reason not to comply, indicated a treaty would be necessary to formalize the matter.

In November 1857, the Tonawanda Senecas entered into a treaty with the United States. Under these terms they were to give up their lands in Kansas

A family portrait on the Tonawanda Indian Reservation, mid-1800s. *Tonawanda Reservation Historical Society.*

Home on the Tonawanda Indian Reservation, circa 1900. *Tonawanda Reservation Historical Society.*

where they were to have removed to and the $400,000.00 that was to help in their removal. In exchange for this, they were allowed up to $256,000.00 to purchase land from the Ogden Land Company. Also, $15,018.36 in compensation was allotted for any loss of improvements they had on the land they were giving up. The treaty was ratified in 1859.

Since the Ogden Land Company had already started selling parcels on the Tonawanda land, the purchasers had to sign off their claim to it as well. There are many notable signatures of the large land barons of New York State: Joseph Fellows, J.D. and Mary Ogden, James S. Wadsworth and members of the Van Rensselaer family. Although this was not a perfect deal for the Tonawanda Band of Senecas, at least now they owned undisputed title to the land they retained because they had purchased it.[88] According to the biography of William G. Bryan, written by George J. Bryan in 1886, William had attended a council at Tonawanda in 1859 after the ratification of the 1857 treaty to express his congratulations. William relayed that one of the chiefs commented on the title to their land by pronouncing, "Now we own our lands from the center of the earth to the heavens."[89]

THE THIRTY-TWO PEOPLE LEFT IN KANSAS

When the United States decided to send the Indians from New York to the land west of Missouri, it was not intended that they should stay; in fact, it was not even assumed that they would survive. It was, after all, in the minds of those in the government, worthless, sterile desert.

Several articles of the day, including one called "Administration of Indian Affairs" printed in the May 1846 issue of the *United States Democratic Review*, stated observations to the following:

> *Obeying the natural law of progress, industry and virtue, we have advanced as rapidly as they have declined. Some of the seaboard tribes and clans have entirely disappeared. Others have transferred their residence by voluntary emigration west of the Alleghanies and the Mississippi River. But a very large portion of the whole number still exist, and our relationship with them have in no wise altered, except that we have augmented in numbers and power, while they have declined.*

The words "still exist" are italicized in the article as if to clarify their astonishment that there were so many Indians left alive. By this point in time, the territory was already being overrun by white settlers. Kansas had become a thoroughfare for the Oregon and Santa Fe Trails. It was well on its way to becoming a territory. Obviously, the United States government never intended the New York Indians to thrive there.

The passage of the Kansas-Nebraska Act in 1854 opened the two new territories for settlement. The settlers now had to decide if Kansas, when

it became a state, would it be free or slave? As the friction between settlers brought the slavery issue to the forefront of the country and the country inched closer to war, the territory itself, without a firm government, was violently split—so much so that it was dubbed "Bleeding Kansas." On July 5, 1859, Kansas adopted an antislavery constitution by an overwhelming vote and set up a temporary state capitol in Topeka. The railroads through the territory were not far off in the future, and Kansas was on its way to statehood.

In the midst of all this turmoil, fewer than three dozen people were living out their lives on a small portion of the vast amount of land that had been allotted to the New York Indians. It didn't matter that this was guaranteed under the treaty of 1838. Settlers had been encroaching or squatting on it for a number of years. In many cases, land patents had already been issued. The remainder of the tract was still vastly unsettled, and the government wanted it back.

On June 14, 1858, a report was given by the secretary of the state to the Department of the Interior. It was called "A Resolution of the Senate Relative to the Claim by the St. Regis Indians to the Land in Kansas." J. Thompson, secretary, stated in the report, "The St. Regis have no claim whatsoever to the lands in Kansas set apart for the New York Indians." In addition, Charles E. Mix, acting commissioner, determined that the St. Regis were included in the treaty as part of the New York Indians, but they had taken no steps for removal and the Canadian portion of the St. Regis Indians "have not the shadow of a right to any part of the tract in question." In the summer of 1859, the Department of the Interior sent an agent to Kansas to see if a reservation had been established. A census was taken of the occupants of the tract, and it was found that only thirty-two people were living on the New York Indian Reserve.

The 1,824,000-acre tract allotted to the New York Indians was encroached upon, and the towns of Fort Scott (1842), Eureka (1857), Center and Iola (1859) were already established. As stated in the treaty of 1838, each person was to be allotted 320 acres of land. It was determined by the report from June 16, 1860, whom the thirty-two people were.[90]

It would take many more years for this matter to be settled, if it ever was completely. In 1873, a document called "Brief on Behalf of Settlers in Kansas, Upon Public Lands of Which It Is Claimed That Certain New York Indians, Have an Interest Under the Treaty Made with the Six Nations of New York Indians, January 15, 1838" was presented on behalf of the settlers' interests. The brief gave the details of the affidavits taken in 1860 from the list of the thirty-two people on the Kansas lands. Of the thirty-two people,

only six who came with the Hogeboom party in 1846 were still there—James King (Cayuga), his half brother Joseph Fox, James Schrimpsher (Seneca), Louisa Schrimpsher (Seneca), Mary Yellowjacket (Cayuga) and Daniel Jack (Tuscarora). Mary Ann Gray (St. Regis) had arrived in the territory prior to the party in 1835, as did Elizabeth Boatman (St. Regis), who arrived in 1837 and had emigrated from the Green Bay territory. The others in the original party that had made it to Kansas and did not return to New York had been forced out by encroaching settlers and settled elsewhere within Indian territory.

Some of the group of thirty-two had arrived later in time. This should not have been a point of objection when this case ultimately went to court. After all, it was land set up for the tribes of New York State. It shouldn't have mattered when they actually arrived. However, it is a point that will be brought up by the government. Arrivals in 1855 were: Michael Gray (St. Regis); Martin Predom (St. Regis); his wife, Mary (Osage); and their daughter, Rosalie. The rest of the settlement of the thirty-two people on the New York Reserve were children of the above families. The children having rights to the land would also be a matter that will be brought up in court. Again, this should not make a difference, but as we progress in time, we will see what the court finally decided.

REQUEST OF THE NEW YORK INDIANS FROM KANSAS

When the Department of the Interior sent its agent to Kansas in the summer of 1859, it was reported that the agent found only thirty-two people, adults and children combined, living on the 1.824 million acres that had been reserved for the "New York Indians." Per the treaty of 1838, the thirty-two people were allotted 320 acres each, leaving over 1.8 million acres under the ownership of the New York tribes. Settlers, by patent or squatting, were already established on some of the land not being used by the thirty-two people, and towns were being formed. Ignoring the treaty rights given to the New York Indians, the purpose of the census on the Kansas lands was to see how many "Indians" were actually there in order to proceed in officially getting the land back in the ownership of the United States.

Those still on the Kansas land were well aware of the purpose of the government in sending their agent in 1859 to take the census and gather the affidavits from them concerning when they came, how long they had been there and their relationship to the other members of their territory. Lewis Denny, Michael Gray (from St. Regis) and Cornelius Seth, acting as representatives of the tribes on the Kansas lands, wrote a letter to the commissioner of Indian Affairs shortly afterward expressing their concerns and their rights under the Treaty of 1838. They retained a copy of the letter for themselves, and it is among the collection of the Kansas University.[91]

This document is not only historically interesting, but it also is important. It is written proof that the government had no intention of honoring the rights of the New York tribes under the Treaty of 1838. It is evidence of

what the Indians had been promised and never received to set up their territory, including the settlement money and that they had been left to fend for themselves the moment they set their feet outside New York State. One of the most insightful parts of the letter is not in the text itself but a notation, written sideways, in the top left corner of the first page. It reads, "Copy of letter from C. Seth L. Denny & M. Gray, 32 Oneidas, 33 St. Regis." It appears there were more people occupying the land then the government acknowledged. The letter reads as follows:

Wyandott K. T.
July 26, 1859
Commissioner of Indian Affairs

Sir
We, Cornelius Seth a Chief of the Stockbridges and Lewis Denny_____ of the Oniedes and Michael Gray of the St Regis in Kansas Territory respectfully, and earnestly call your attention to the following statements and petitions and statements.

It is, perhaps, known to you that the Indians known as "New York Indians" to whom certain lands in the then Indian now Kansas Territory were granted by the Treaty made on the January fifteenth, day in the year eighteen hundred and thirty eight at Buffalo Creek, state of New York; are composed of the remnants of several Tribes or Nations. In accordance with the stipulations of said Treaty the bands whom we represent came to this territory within the time specified in the treaty but have not as yet found the government as ready to fulfil Treaty stipulations in that, that we have not yet had the three hundred and twenty acres of land per head secured to us the Treaty provides. We are very desirous and petition that this should speedily be done for the following reasons.

1ˢᵗ The White people are continually intruding upon us by settling upon our lands and by taking our timber and committing other depredations.

2ⁿᵈ Some of the Indians who are entitled to the lands are becoming fearful that the promises of the Government will not be fulfilled, Speculators (some of them Agents of the gov't) are taking advantage of those fears and have promised to procure the lands for them provided that these Indians will give them twenty acres of each share for their services while these Indians are entitled to the lands free and should have them without paying any fee Gen Seth Glover of the Paoli Agent offered an agreement to one of us (Cornelius Setter) to get him to sign it

3rd the longer the delay, the more claimants there will be for the lands; for persons who are not N.Y. Indians at all are influencing some of the proper Claimants to get them allowed shares promising a certain amount of money per acre if they succed in getting them admitted thus invalidating & endangering the rights of the legal claimants by practising fraud upon the Gov't and they are encouraged to do so by Gov't agents.

Again; We petition that the Stockbridges of Kansas, the Oneidas & St Regis have their lands assigned together in one compact body on the Little Osage River for the reasons

1st That we may if we do choose——, govern ourselves independently of the Munsees and others who have already been persuaded to make arrangements for selling the entire claims of the N.Y. Indians to their same speculators and that without consulting us or those whom we represent and we wish to be so situated that they cant interfere with us.

2nd That by having the lands in a compact form we may not be annoyed by white people settling in among us, availing themselves of the privilege specially granted to us by said treaty of Jan 15 1838.

We also earnestly ask that our proportion of the four hundred thousand dollars promised to us by said Treaty of 1838, for school purposes may soon be given to us. Our children have had no opportunities for instructions for several years, and are growing up ignorant which we very much lament.

In addition to this we petition that all the other stipulations of said Treaty be fulfilled. By referring to that Treaty you Hon. Sir will see that we were promised farming utensils, a grist & saw mill a church, a doctor and a blacksmith.

We hope that you will believe with us that it is time, that that Treaty with all its stipulations should be fulfilled. Some of us have again & again begged for our homes to be secured to us and now when almost all our men are dead we begin to have some little hope

We desire that the lands should be secured to us in such a manner as that it cannot be sold to any but the President of the United States

We would here state that we are the chiefs by birthright of the Bands we represent and that we and the persons whose names are given in the lists herewith enclosed came to this Territory between the year 1838 and 1860. Our bands acknowledge as chiefs.

This we stated to the Special Agent——(A.S. Stevens) and he seemed inclined when we met him at Paoli to recognize us as chiefs but when we met him at Quindero he seemed to set us aside and recognize as such a set elected by persons who are mostly citizens of the United states and

Indians who are not New York Indians and whom our bands do not own as Leaders. It seems to us that he does so because we will not be made tools in his hands to cheat our people and thereby enrich the speculators as some others have done. You will be astonished to learn that some of those who are claimants of the New York Indian lands have sold their entire shares at very low prices receiving in part pay goods from a merchant at Quindaro. We must believe that we were brought to Quindaro to suit the purposes of this man and the other speculators. Some of those who sold the land are Brothertowns who are citizens of the United States have homes in Wisconsin, and reside there, and though now here instead to return there We told Mr Stevens that they had no right to a portion of the New York lands, but he paid no attention to us. The more he admits as New York Indians the more shares there will be to be bought.

As expected, their letter and wishes were ignored. The decision to sell the Kansas land had already been made. It was now the New York Indians' problem of where to go and how to get there. Based on the past actions of the United States, we can assume the government didn't care if they made it to their destination alive.

THE KANSAS NEW YORK INDIANS LAND CLAIM

D espite the letter from Lewis Denny, Michael Gray (from St. Regis) and Cornelius Seth, representatives of the tribes on the Kansas lands, to the commissioner of Indian Affairs in June 1859, the land was going on the market. The census and report that had been taken that same summer by the agent from the Department of the Interior on the occupants of the New York Reservation in Kansas was submitted to the department in June 1860. It was immediately decided that the more than 1 million acres in Kansas would be turned over to the General Land Office for sale to the public.

On September 14, 1860, thirty-two certificates of allotments were issued to the New York Indians in Kansas for 320 acres each. Some of the settlers who had already encroached began filing their claims as well in Fort Scott, and the remaining Indians were forced out. Interrupted by a drought in 1860, the slavery debate, the border war and the Civil War, it would take almost thirty years for the New York Indians' land claim to be heard by the Court of Claims.

According to a bill that was presented to the House of Representatives on January 8, 1872, it was proposed for the settlers to purchase the land occupied by them not to exceed 160 acres each at a price of $2.50 an acre, later amended to not less than $3.75 an acre. The proceeds were to be put in trust "for the benefit of the Indians." If there were any of the thirty-two Indians left who had received a certificate in 1860, they would be issued a patent.[92]

The "Act to Provide for the Sale of Certain New York Indian Lands in Kansas" was signed by the president on February 18, 1873. The act also stated,

Left to right: Kahikowa, Kahnekenhawi, Tekanewhasere and Sesi. Written on back, "If you don't believe me that I said I was a soldier, here I am." *Akwesasne Cultural Center.*

"Moneys that shall arise from such sales shall be paid into the treasury of the United States, in trust for, and to be paid to, said Indians respectively, to whom said certificates were issued, or to their heirs, upon satisfactory proof of their identity to the Secretary of the Department of the Interior, at any time within five years from the passage of this act." However, if the proof wasn't provided in the required amount of time, the money would become part of the public money of the United States. No wonder it took so long for this case to be heard. The government may have been waiting out the five years.

The following is an excerpt of the case of the *New York Indians v. the United States (1898)*. It gives a good summary of what happened next:

> *A treaty was concluded September 2, 1863, with the New York Indians who had moved to Kansas under the treaty of 1838, for the purpose of extinguishing their title to lands in that State. This treaty was based on the treaty of November 5, 1857, with the Tonawandas, and was sent to the Senate for ratification, but action was suspended upon it "until a treaty could be concluded with all the New York Indians to arrange all matters between them and the United States which required adjustment." Ex. Doc. Y, p. 2, 40th Cong. 3d session.*
>
> *In pursuance of this policy, the President, in May, 1864, directed a commissioner to proceed to the State of New York for the purpose of negotiating a treaty with the New York Indians. These Indians had been previously notified on April 26, 1864, by the Secretary of the Interior that he deemed it proper to advise them, through their agent, "that it is the desire of the Government to extinguish their title to a tract of land in Kansas, ceded to them by the treaty of January 15, 1838;" and that a treaty had already been made for that purpose with the fragments of bands of these Indians residing in Kansas. Ex. Doc. No. 1, 38th Cong. 2d sess. p. 188.*
>
> *The treaty with the Indians living in New York was not concluded, but in his annual report to Congress the secretary of the interior on December 6, 1864, spoke of the efforts to extinguish the title of these Indians to the Kansas lands and considered their claims as "being undeniable and just." Ibid. This opinion was reiterated by the Commissioner of Indian Affairs on December 5, 1866, in his annual report. (p. 61.)*
>
> *In November 1868, the president again attempted to negotiate a treaty or treaties with the Senecas and other New York Indians with reference to "their claims arising under the treaties of 1838 and 1842." Ex. Doc. Y, p. 10, 40th Cong.3d sess. And thereafter, a treaty was concluded December 4, 1868, according to the instructions issued to the commissioner appointed*

to negotiate it, by which the United States agreed to pay the sum of $320 to each Indian, including half-breeds, of the Six Nations in New York and Wisconsin. Ibid. p. 1.

The commissioner appointed to negotiate this treaty reported to the Indians in council that "the reason why the New York Indians had not been removed to their Kansas reservation was because squatters had obtained possession of their lands, and the United States was unable to drive them off, and keep them off." Ibid. p. 10.

This treaty, however, was not ratified by Congress, owing presumably to the passage of a general law that denied the right of any Indian tribe or nation to be recognized as an independent nation for treaty-making purposes. Act of March 3, 1871, c. 120, 16 Stat. 544, 566.

Charles and William B. King, attorneys on behalf of the Kansas settlers, filed a brief, used the list and the details of the relationships of the thirty-two people and said it was not probable in their minds that the Indians were forced off by any violence and requested that the money, per the Act of 1873, be reduced for the settlers to pay to $1.25 an acre.

Thomas Indian School. *Cattaraugus County Historical Museum.*

Thomas Asylum for Orphan & Destitute Indians (changed to Thomas Indian School in 1905), administration building. It is located on Route 438 on the Cattaraugus reservation and is currently used for offices. *Library of Congress.*

True to history, time dragged on in this land claim case as well. An article that appeared in the *New York Times* on January 29, 1883, stated, "The survivors of the confederated Indian tribes of New York State known as the Six Nations have a claim against the United States Government for a large sum of money. It is expected that this claim will be vigorously pressed before Congress, and at a meeting of representatives of the various tribes held a week or so ago at the Onondaga Reservation a petition to the national legislators was prepared, and a committee of delegates appointed to push the matter."

The newspaper article goes on to discuss the particulars of the matter that have been mentioned in the previous chapters. The article then states, "The representatives now claim the money received from these sales. In their petition they ask Congress to appropriate the sum 'as a fund to build a high school' for the benefit of the youth of the Six Nations. The sum, which, with interest, must be more than $3,000,000, would seem to be an ample amount for the purpose." The question here is not just about the money but also what happened to the stock.

20

THE FINAL CHAPTER

What About the Money and Stocks?

B efore we reach the end of this story, a look should be taken as to the money itself. Were the New York tribes ever paid? What happened to the stock investment per the 1838 treaty? The February 1861 issue of *Harper's New Monthly Magazine* provides proof of the fact that the *Cobell v. Norton* case is not the first incident to question where the money went. In the article "Monthly Record of Current Events," the same amount of money that was referred to in the *New York Times* article in 1883 and that was cited in the last chapter is referred to. The *Harper's* article read:

> *A large embezzlement of the public funds has taken place. A sum of more than $3,000,000 has long been funded, the interest of which is appropriated to the payment of annuities to various Indian tribes. This was invested in State stocks, the certificates of which were put in charge of Godard Bailey, a clerk in the Department of the Interior, said to be a connection of Mr. Floyd, Secretary of War. Russell, Majors, and Co. held large contracts with the Government for conveying supplies across the plains of Utah. In order to raise money to carry out these contracts they had been accustomed to give drafts upon the Government, payable in three or four months, the sums to be charged to the amounts due upon their contract at the time of payment. These drafts were officially accepted by Mr. Floyd. It at length became impossible to raise money upon these drafts. Bailey, apparently without the knowledge of the Secretaries of either of War or of the Interior, abstracted a large amount of the stock certificates in his charge, and placed them in the hands of the contractors,*

*receiving a similar amount in the accepted drafts upon the Secretary of War.
The stocks thus purloined were sold in the market. The total amount thus
purloined is stated at $870,000.*

This sounds all too familiar. It is far too similar to the missing funds from
the Bureau of Indian Affairs and the antics of Jack Abramoff. Obviously, the
issue of missing money held in trust for the Indians by the United Sates goes
a lot further back than the last few decades.

Using a Consumer Price Index calculator, the purchasing power of
$870,000 in 1861 would be equivalent to $24,100,000 in 2014. The question
here is, did this particular matter ever get settled and the guilty parties
brought to justice? The matter of the stolen stock, which was in trust for the
tribes, is an issue of its own to be looked at. What of the stock itself under
the 1838 treaty, the money that was to be appropriated for their removal and
the profit of the Kansas land sales?

On March 3, 1883, the case was turned over to be heard by the Court of
Claims. The committee was to find the facts and render a judgment—the
statute of limitations could not be pled as a bar to any recovery. According to
the case of the *New York Indians v. the United States (1898)*, we see the following:

> *In a communication dated January 29, 1884, addressed to the Secretary
> of the Interior for transmission to the Senate, the Commissioner of Indian
> Affairs reviewed the claims of the New York Indians under the treaty of
> 1838, and adhered to the opinions of his predecessors, in that there was a
> failure on the part of the Government to provide homes for those who went
> to Kansas, and that no consideration had been given the New York Indians
> for the cession of the 500,000 acres of Wisconsin lands. He referred to the
> settlement with the Tonawandas, and stated that he saw "no reason why
> the other tribes should not receive the same relief."*

Nine more years passed before the court reached its conclusion. On July
13, 1892, the report was presented to Congress, titled "Indian Beneficiaries
Under Treaty Concluded at Buffalo Creek."[93] On January 28, 1893,
Congress passed an act that authorized the Court of Claims to hear and
determine the cases.[94]

Although the monetary amounts were mentioned per the treaty, no
mention was made concerning the stipulation to the investment in stocks
on their behalf. The 1898 court case recites part of the petition of the New
York Indians:

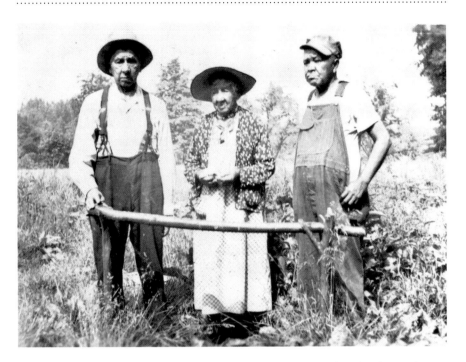

Left to right: Seneca sachem Solon Skye; Mother Julia, Seneca Snipe Clan Mother; and Seneca sachem Henan Scrogg at the home of Solon on the Tonawanda Reservation. *F.H. Benham Collection, Tonawanda Reservation Historical Society.*

Fourthly. The United States agreed to pay to the several tribes or nations of the claimants, hereinafter mentioned, on their removal west, the following sums respectively, namely: To the St. Regis tribe, five thousand dollars ($5,000); to the Seneca nation, the income annually of one hundred thousand dollars ($100,000), (being part of the money due said nation for lands sold by them in New York, and which sum they authorized to be paid to the United States); to the Cayugas, twenty-five hundred dollars ($2,500) in cash, and the annual income of twenty-five hundred dollars ($2,500); to the Onondagas, two thousand dollars ($2000) in cash, and the annual income of twenty-five hundred dollars ($2,500); to the Oneidas, six thousand dollars ($6,000) in cash, and to the Tuscaroras, three thousand dollars ($3,000).

Fifthly. The United States agreed to appropriate the sum of four hundred thousand dollars, ($400,000) to be applied from time to time by the President of the United States for the following purposes, namely: To aid the claimants in removing to their new homes and supporting themselves the first year after their removal; to encourage and assist them in being taught

Lacrosse Stick Factory, Cornwall Island, circa 1930s. This factory produced quality Mohawk-made sticks for the United States, Canada, England and Australia. *Akwesasne Cultural Center.*

to cultivate their lands; to aid them in erecting mills and other necessary houses; to aid them in purchasing domestic animals and farming utensils and in acquiring knowledge of the mechanic arts.

That of the sum of $400,000, agreed by the treaty of Buffalo Creek to be appropriated by the United States for the purposes aforesaid, only the sum of $20,477.50 was ever so appropriated, except as hereinafter stated, and of this sum only $9464.08 was actually expended.

The petition further alleged that the Tonawanda band had been paid $256,000 for their interest in the land; that settlement had also been had with the Senecas, and that a special act had been passed authorizing the Court of Claims to find the facts and enter up judgment, without interest, and that the statute of limitations should not be pleaded as a bar to any recovery.

The Court of Claims dismissed the case, and the New York Indians appealed. The Appeals Court for the Court of Claims reversed the original decision.

The judgment of the Court of Claims is therefore reversed, and the case remanded with instructions to enter a new judgment for the net amount

Thomas Indian School. The young man in the center of the first row holds a football dated 1901. A formal athletics program was introduced into the curriculum in 1902. *New York State Archives.*

actually received by the Government for the Kansas lands, without interest, less the amount of lands upon the basis of which settlement was made with the Tonawandas, and other just deductions, and for such other proceedings as may be necessary, and in conformity with this opinion.

On December 30, 1900, an article appeared in the *New York Times* "United State to Pay Indians $2,000,000." According to the article, Congress appropriated the money to be paid according to the ruling of the court, minus the sum that was paid to the attorney who represented the Six Nations. The money was to be held by the Treasury Department pending the enrollment of the individual beneficiaries. To throw a kink into the works, the Brothertown Indians then filed a motion to join in the action. As of 1900, it was estimated there were eight thousand Indians as joint creditors, five thousand of whom were still residents of New York State, the remainder residing in the West. Once again, the matter became an entangled mess.

163

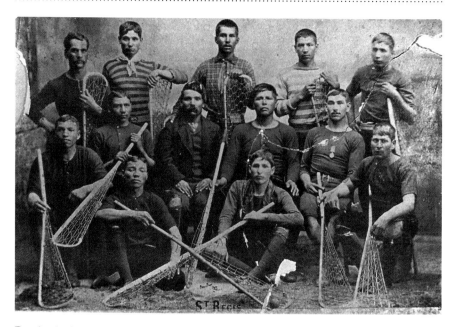

Despite the lack of protective gear, the game of lacrosse was played in 1900 with the same intensity as it is today. *Akwesasne Cultural Center.*

By January 5, 1901, according to the *New York Times*, Frances M. Morrison of Worchester, Massachusetts, who represented the Brothertowns, and James B. Jenkins of Oneida, New York, representing the Six Nations, were battling out the judgment of the court. Morrison contended the judgment of the court should entitle the other former New York Indians to receive a share; this included 217 Stockbridges, 132 Munsees and 360 Brothertowns, along with the current New York Indians still considered the Six Nations. This same article then makes a very interesting comment:

> *Mr. Morrison asks why the payment of $199,874.44 on May 29, 1900, was made by the State Department, and, if the contract has been fulfilled, why the beneficiaries have received nothing under it. An investigation, he concludes has been demanded and the whole matter laid before the Secretary of the Interior and the Commissioner of Indian Affairs.*

It appears again, by Morrison's comments, that a portion of this money was appropriated, and after eight months, none of the tribes had seen a dime of it.

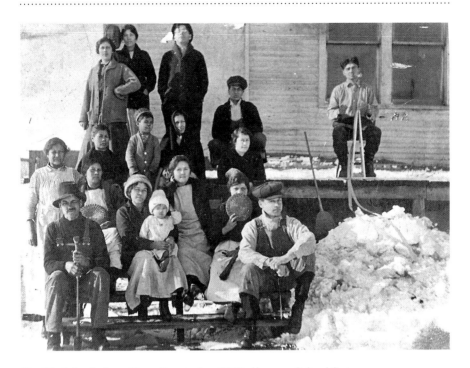

The Black family from Drum Street, circa 1900. *Akwesasne Cultural Center.*

To dwindle down the money even more, according to the *New York Times* on October 14, 1902, the Oneida Indians of Wisconsin would also share in the money that was awarded because of land they surrendered in Wisconsin to remove to Kansas, which they never did. Their portion of the funds was $300,000.

Per a new article in the *New York Times* on July 20, 1905, the final award amount was $2,500,000. Throughout the year of 1905, as cited in many articles by the *Post Standard* newspaper of Syracuse, every Indian in New York began to receive their share. Money allotted to the children was given to the children's parents on their behalf. The Oneidas received $100 apiece in August of that year.[95]

The Onondagas received $20,000 in October to divide among their people.[96] Around the same time, the *Post Standard* reported that the Canadian Indians had put in a claim for a cut of the funds.[97]

According to *Historical Sketches of Franklin County (1918)*, in 1905 and 1906, a total of $179.33 was paid to every "Indian man, woman and child" of the St. Regis.

Although the money for the sale of the land itself was eventually disbursed, the money that was invested on their behalf in stock per the 1838 treaty is

Akwesasne Freedom School, late 1970s. The goal is to enable young Mohawks to become fluent in their own language, along with learning other subjects. *Akwesasne Cultural Center.*

still unaccounted for. So the question remains, did the stock still exist in 1905 when all was said and done? If not, it would be interesting to find out what happened to it.

Epilogue
WHAT BECAME OF ELEAZER WILLIAMS?

S ome versions of the story of Reverend Eleazer Williams say he resigned his post at the Duck Creek St. Thomas Church on September 8, 1833, and other versions say he was relieved of his duties there. Regardless of what the case was, in October 1834, he left Green Bay to return to New York. Feeling ill along his journey, he did not arrive at St. Regis until December. His illness continuing, he removed to Albany and remained there under a doctor's care. He returned to St. Regis in June 1835 with the hope of starting a school. While he was there, he looked for documentation for his father Thomas Williams's service in the War of 1812. By 1836, he desired to return to Green Bay to the family he left behind, or so he said. Other versions tell of his return to Green Bay because of his involvement in the treaty of 1836 at Duck Creek.

Eleazer's involvement in the 1838 removal treaty can be proven by the treaty itself. There is also extensive documentation on the life of Williams showing his cooperation with the Ogden Land Company and the United States government. Both the Oneidas at Green Bay and New York no longer trusted him and professed he was not their spokesmen. However, the most romanticized portion of his life was just about to begin. Through government documents, newspapers, magazines, Eleazer's journals and family papers, records at the Wisconsin Historical Society and the Neville Museum in Green Bay, a complex story emerges about a very complex man.

On June 22, 1841, Eleazer set out from Green Bay on the *DeWitt Clinton* and headed back to New York. Again, he became ill and spent several weeks

at St. Regis to recover. Because of this, he was unable to keep his appointment with Thomas Ogden and quickly returned home to Green Bay. Allegedly, his quick departure was caused by a gentleman who was there awaiting his arrival, the Prince de Joinville of France. According to accounts, Joinville was there to see if it was true that Eleazer Williams was the Lost Dauphin. Other accounts would say that the prince said this was not true, that his only interest in Williams was in regard to his involvement as a missionary to the Indians. Some accounts say that while in Buffalo, New York, Williams heard of the prince's planned trip via the Great Lakes to the Wisconsin territory and strategically placed himself on the same boat as the prince.

The Lost Dauphin story filled the papers with questioning articles. Many of the articles are said to have been written anonymously by Eleazer himself to garner the public's attention. The most notable story, the one that really brought the controversy into the public eye, was published in *Putnam's Monthly Magazine* in February 1853, titled "Have We a Bourbon Among Us?" The text contained portions of an interview with Eleazer Williams himself. Since the article's first appearance, and even today, the story's truth has been debated by historians.

"Have We a Bourbon Among Us?" contended that Williams was the Lost Dauphin who was smuggled to America and that his native parents were not his true parents. In the native set of parents, Eleazer's father was Thomas Williams, who descended from Reverend John Williams of Deerfield, Massachusetts. Thomas's family was captured in 1704 by a band of Mohawks. As previously stated, many were released, except a daughter, Eunice, who preferred to remain with her captors and was adopted. Her daughter Mary is said to have married a chief and is the mother of Thomas Williams, father of Eleazer, who was born at Caughnawaga about 1789. Was Eleazer the heir to the French throne or born at Caughnawaga? Eleazer used both versions as it suited him.

When the reporter interviewed Williams, he asked of his memories of his childhood. Eleazer supposedly had none, saying, "My mind is a blank until thirteen or fourteen years of age." From the story, he suddenly came to his senses after plunging off a high rock into Lake George. He then tells the interviewer his recollection of his true birth did not come to him until later in life, in 1844, when looking at some prints at the home of a Mrs. Perry of Newport, New York. There, he recognized a portrait that turned out to be the jailer who had him incarcerated in France before he was whisked away to America as a child. Later, the French declared that he had died. The interview also explains Williams's meeting with Prince de Joinville of France.

According to a Senate report dated February 24, 1858, only $1,000 had ever been paid to the St. Regis in 1846 out of the $5,000 that was designated to them under the treaty of 1838. Since before the 1846 payment, and afterward, Eleazer Williams had applied to the president for the remaining $4,000, claiming it belonged to him. The report states this was for services rendered by Williams in the treaties of 1827, 1831 and 1832 for the Wisconsin territory and the treaty of 1838 with the New York Indians. If you recall from the treaty of 1838, the full $5,000 was to go to the St. Regis. By 1848, the organization Propagation of the Gospel Among the Indians and Others in North America had suspended Williams's stipend for support of his missionary work.

His wife, Mary Jourdain (great-granddaughter of a Menominee chief), who had only been fourteen when they married in 1823, had been told one day she would not be going to school and instead become the wife of the minister. By all accounts, she had not been close with her husband throughout their entire marriage, and she spent her whole life at the homestead in Green Bay. In her journal, in the possession of the Wisconsin Historical Society, she refers to her husband as "Mr. Williams." Eleazer's interest in ministry work wouldn't last, and his stipend was taken away again in 1853 due to his "absence from his duties," the same year the Bourbon story appeared in *Putnam*.

In 1850, Eleazer headed back east to offer his services to the government to remove the Senecas who remained in New York. His offer was rejected, and he again returned to Green Bay. Eleazer and his wife, Mary, appear on the 1850 and 1855 censuses in Brown County, Wisconsin. Shortly after this time, Eleazer, no longer a point of interest, returned alone and destitute to Hogansburg, New York. He commenced a school at St. Regis, and his stipend was renewed based on good words from his neighbors to the Diocesan Society of New York. The Bourbon fanfare lasted for two or three years until it finally died down, mostly due to public suspicion to his claim. It was revealed that he was just one of many who claimed to be the Lost Dauphin.

By 1858, there were two bills before Congress in regard to Eleazer Williams. One, dated April 17, 1858, bill 508, title "For the Relief of Eleazer Williams, Sole Heir of Mary Ann Williams and Thomas Williams, Deceased." The object of the bill was to appropriate $14,000 for his father's services in the War of 1812. With his mother now deceased, he was applying to collect his father's pension of $219 a month. The committee approved the bill, giving Thomas Williams the honor he

deserved and, by doing so, also proving by the evidence presented with the claim that Eleazer Williams was the son of Thomas Williams and not the heir of France.

The other bill, dated May 29, 1858, titled "For the Relief of Eleazer Williams," was to appropriate the remaining $4,000 out of the $5,000 that had been designated to the St. Regis under the treaty of 1838. It passed the Senate on April 16, 1858. Eleazer Williams died on August 28, 1858, never receiving any of the money. He died in poverty in his home, which had been given to him by the Episcopal Church, on the St. Lawrence River, six miles from the St. Regis reservation. According to a news article in the *Oshkosh North Western*, dated January 7, 1937, his house was due to be torn down, but by an article from the *New York Times* on April 13, 1941, stated that it was still standing but falling to pieces.

Reverend Eleazer Williams was originally buried under pine trees in the Hogansburg Cemetery. In 1947, his body was exhumed and his remains removed to Green Bay to the Oneida Holy Apostle Cemetery in Wisconsin under the authorization of the Episcopal Church. His wife died on her farm in Green Bay on July 21, 1886.

APPENDIX

The following treaties were microfilmed in their original state as they were transcribed and recorded in the volumes of Indian treaties now held at the New York State Archives. You can print them from the microfilm collection Iroquois Indians: A Documentary History of the Diplomacy of the Six Nations and Their League. Many of the treaties mentioned in this book can found on the Internet. I have reprinted the treaties with the St. Regis, as they are not as easily found.

COPY OF TREATY BETWEEN INDIANS OF ST. REGIS AND THE STATE OF NEW YORK (DECEMBER 10, 1818) (XIII)

Signed in Albany on March 15, 1816.[98]

A Treaty made and Executed between Daniel D. Tompkins Governor of the State of New York in behalf of the People of the Said State of the one part, and Peter Tarbell Jacob Francis and Thomas Williams for and in behalf of the Nation or Tribe of Indians, known and called the "St. Regis Indians," of the second part (at the City of Albany, this fifteenth day of March in the Year of Our Lord One thousand eight hundred and sixteen) Witnesseth.

Article 1st. The said Tribe or Nation of St. Regis Indians, do hereby sell and convey to the People of the State of New York, for the Consideration

hereinafter mentioned, a certain piece or parcel of their reservation, called the one mile square, Situated in the County of Franklin on Salmon River, to have and to hold the same to the said people of the State of New York, and their assigns forever. And Also, a separate and additional tract of Land of their said reservation, Situate in the County aforesaid containing Five Thousand Acres —of the Easterly part of their said reservation; adjoining the aforesaid Mile Square of Land within the territorial limits of the State of New York; to be measured from the East Boundary line of said reservation, so as to make the west boundary line of said five thousand Acres to run due north and south, to have and to hold the said Five thousand Acres of Land to the said People of the State of New York and their assigns forever.

Article 2nd. The said Daniel D. Tompkins Governor as aforesaid for and in behalf of the People of the State of New York covenants and agrees with the St. Regis Nation of Indians that the said People for the said several tracts of one mile square of land and of five thousand Acres of Land herein before granted and Conveyed Shall pay to the said Nation annually forever hereafter the Sum of One thousand three hundred dollars, at French Mills on said premises, the first Payment of the said annuity to be paid on the first Tuesday of August next, and the whole annuity to be paid on the first Tuesday of August in each year thereafter.

Article 3rd. The said St. Regis Tribe or Nation of Indians, Also covenant and agree to depute and Authorize three of the Chiefs or Principal Men of their Tribe to attend at the times and places aforesaid to receive the said Annuity, And that the receipt of the said Chiefs or principal Men So deputed shall be considered a full and satisfactory discharge of the People of the State of New York from the Annuities which may be so received.

In Witness Whereof the said Daniel D. Tompkins Governor as aforesaid in behalf of the People of the State of New York, and Peter Tarbell, Jacob Francis and Thomas Williams. Chiefs and Warriors of the said St. Regis Tribe or Nation of Indians for and in behalf of said Tribe or Nation of Indians have hereunto and to a copy hereof Interchangeably Set their Hands And Seals the day and year first above written.

DANIEL D. TOMPKINS [L.S.]
PETER his X mark TURBELL [L.S.]
JACOB his X mark FRANCIS [L.S.]
THOMAS his X mark WILLIAMS [L.S.]

Sealed and Delivered In the Presence of (The word "Tuesday" in one place and "tues" in two others Interlined before Execution also the alterations which make the whole amount of the Annuity, Payable next August also made before Signing)

JOHN TAYLER
SIMEON DEWITT
MICHAEL HOGAN

STATE OF NEW YORK, *SS.*
I Smith Thompson Chief Justice of the Supreme Court of said State do certify that on the eighteenth day of March 1816 before me appeared Michael Hogan known to me personally who being duly sworn said that he saw Daniel D. Tompkins duly execute the within treaty and that he also saw Peter Tarbell Jacob Francis and Thomas Williams known to him to be Chiefs of the St. Regis Nation or Tribe of Indians duly execute the same and that John Tayler Simeon DeWitt and the Deponent Subscribed their names as Witnesses to the Execution of said Treaty and there appearing no material alterations therein except those noted as having been made previous to Execution, I do allow the said Treaty to be recorded.
SMITH THOMPSON.

[Written in the book margin is the following: "Recorded December 10,1818 and agrees with the Original Compared therewith by ARCH. CAMPBELL Dep. Secretary."]

Copy of Treaty between Indians of St. Regis and State of New York (December 10, 1818) (XVIII)

Signed at Albany on February 20, 1818.[99]

At a treaty held at the city of Albany the 20th day of February in the year of our Lord one thousand eight hundred and Eighteen Between His Excellency DeWitt Clinton Governor of the State of New York on behalf of the People of the said state and Loran Tarbell Peter Tarbell Jacob Francis and Thomas Williams on behalf of the Nation or Tribe of Indians known and called the St. Regis Indians. It is covenanted agreed and concluded to wit.

The said St. Regis Indians sell and convey to the People of the State of New York Two thousand acres out of the lands reserved by the said Indians to be bounded as follows to wit. *On* the North and South by the North and South bounds of said reservation on the east by the lands ceded by said Indians to the people of the state by entreaty dated the 16th day of March 1816 and on the west by a line running parallel thereto and at such distance therefrom as to contain the said Two thousand acres. *Also* four rods wide of land through the whole length of their Reservation for a public road to the west bound thereof, together with four rods wide of land for the same purpose commencing at the boundary line near the village of Saint Regis to run in a direction so as to intersect the aforementioned road a little Westerly of the place where it shall cross the Saint Regis River which will be about one mile and three quarters in length. On condition that both the said roads be laid out by Michael Hogan with the assistance of Loran Tarbell and such other persons as his Excellency the Governor of the said State shall appoint and further that in case a Turnpike gate or gates should be established on said road all the Indians of the said Tribe shall be forever allowed to pass free of toll and on the further condition that the settlers on the lands they have now and heretofore sold shall be compelled before the State gives them or any other person title thereto pay up the arrearages of rent due on the lands occupied by said settlers.

In consideration of which cession or grant it is hereby covenanted on the part of the said people to pay to the said Indians annually forever hereafter on the first Tuesday of August at Plattsburgh an annuity of two hundred dollars. And it is further covenanted by and between the said parties that the annuities payable to the said Indians in consequence of the former treaty between them and the state shall hereafter be paid them on the said first Tuesday of August at Plattsburgh instead of the places where they are made payable by such treaties.

In testimony whereof the said Governor on the part of the People of the said State and the said Loran Tarbell Peter Tarbell Jacob Francis and Thomas Williams on the part of the said St. Regis Indians have hereunto set their hands and seals the day and year first above mentioned.

DEWITT CLINTON [L.S.]
LORAN his X mark TARBELL [L.S.]
PETER his X mark TARBELL. [L.S]
JACOB his X mark FRANCIS [L.S]
THOMAS his X mark WILLIAMS [L.S.]

Sealed and delivered in the presence of
the name "LORAN TARBELL" twice interlined

SIMEON DEWITT
MICHAEL HOGAN
WM. DEWEY GRAY Interpreter

State of New York *SS*

On this 23rd day of February 1818 personally appeared before me
Archibald Campbell one of the Masters in Chancellery for the said State
Michael Hogan to me known to be one of the subscribing witnesses to the
within treaty who being duly sworn first that he saw the said DeWitt Clinton
Governor and Loran Tarbell, Peter Tarbell, Jacob Francis and Thomas
Williams (Chief of the St. Regis Indians) Sign seal and deliver there within
Treaty that they severally acknowledged to have Executed the same for the
uses and purposes therein mentioned. That he was well acquainted with all
the parties executing the said treaty and that Simeon DeWitt and William
Leavy Gray together with this Deponent Signed their names as witnesses
to the execution thereof. And I have Examined the within Instrument and
finding no alterations therein except what is noted before its execution I
allow the same to be Recorded.

ARCH'D CAMPBELL

[In margin] Recorded December 10, 1818 and agrees with the original
compared therin by ARCH'D CAMPBELL, Dep. Sect.

Copy of the Report of Special Committee Appointed by the Assembly of 1888 to Investigate the "Indian Problem" of the State.[100]

Know all men by these presents We the undersigned chief warriors of the
Tribe called St. Regis Indians constitute and appoint Thomas Williams
Michel Cook Lewis Doublehouse & Peter Turbell as our true and lawful
attorneys to go to Albany and sell such quantity of our Lands to the People
of this State as they may think proper and to transact all other business which

shall be thought best for the welfare of our Nation and whatsoever our said attorneys shall lawfully act or do we will Ratify and confirme—Done at St. Regis in General Counsel this eight day of March 1824—

CHARLES his X mark SAGOHAWITA
IGNACE his X mark GAREWIIS
JOSEPH his X mark DERN
EOVER his X mark TEGANAGEN
THOMAS his X mark TURBLE
BAPTIST his X mark SATELWGUIES
LEWEY his X mark SAHONRANE
ELEAZER his X mark SKARESTGOWA
ETER his X mark TREWIRTI
LORAN his X mark COOK
CHARLES his X mark WILLIAMS

In the presents of
J. HADCOCKS
ELEAZER WILLIAMS
JARVIS his X mark WILLIAMS
THOMAS his X mark TARBLE
LEWIS his X mark TARBLE

STATE OF NEW YORK}
ALBANY COUNTY }
Be it remember that on the sixteenth day of March One thousand eight hundred and twenty four came before me Eleazer Williams one of the subscribing witnesses to the execution of the within power of Attorney to me known who on his oath says that he saw Charles Soghowita Ignace Garawiis Joseph Bern, Eover Taganagen Thomas Turbell, Baptist Sateticoquies. Lewey Sahourance, Eleazer Skaustogowa, Peter Thwate, Loren Cook, Charles Williams, Jarvis Williams Thomas Tarble & Lewis Tarble Severally execute the within power of Attorney for the uses and purposes therein mentioned and that they are all personally known to him and that he together with J. Hadcocks have subscribed their names to the said power as witnesses all which I do accordingly certify.

GARRIT V. DENNISTON—
Commissioner &c.

True copy of treaty between Indians of St. Regis/Akwesasne and the State of New York, March 16, 1824.[101]

At a treaty held at the City of Albany on the 16th day of March in the year of the Lord one thousand eight hundred and twenty four Between his Excellency Joseph C. Yates Governor of the State of New York and the Tribe of Indians called Saint Regis Indians by their duly authorized Deputies and agents Thomas Williams, Mitchel Cook, Lewis Doublehouse and Peter Turbel. It is covenanted and agreed as follows to wit.—
The said Tribe Indians sell and do hereby convey to the people of the State of New York All the right title and interest claim and Demand whatsoever of in and to All that certain Tract of land in the Town of Massena in the County of St. Lawrence known and distinguished as the Mile Square reserved to the aforesaid Indians with their mill on Grass River in and by a Treaty executed on the Thirty first day of May in the Year of Our Lord One thousand seven hundred and ninety Six between the said Indians and Abraham Ogden Commissioner appointed under the authority of the United States and Egbert Bensen, Richard Varick and James Watson Agents of the State of New York and William Constable and Daniel McCormick purchasers under Alexander McComb together with the Mills thereon and all other appurtenances thereunto belonging—
In consideration of which promises the said Governor of the State of New York now pays to the said Tribe of Saint Regis Indians the Sum of One thousand nine hundred and twenty dollars as the consideration in full for the said Tract of land with the appurtenances as aforesaid the receipt whereof the said Thomas Williams Michel Cook, Lewis Doublehouse and Peter Turbel the Deputies and Agents of the said Tribe of St. Regis Indians, do hereby acknowledge—
In testimony whereof the parties to these presents have hereunto set their hands and Seals the day and year first above written.

JOSEPH C. YATES [L.S.]
THOMAS his X mark WILLIAMS [L.S.]
MICHEL his X mark COOK [L.S.]
LEWIS his X mark DOUBLEHOUSE [L.S.]
PETER his X mark TURBEL [L.S.]

Sealed and Delivered in the presence of
ELEAZER WILLIAMS
JOHN HADCOCKS

State of New York}
Secretary's Office }

I certify the proceeding to be a true Copy of a certain original Treaty on file in this office.

ARCH'D. CAMPBELL
Dep. Secretary
Albany, April 1, 1824

Copy of treaty between Indians of St. Regis/ Akwesasne and the State of New York, March 16 1824.[102]

At a treaty held at the city of Albany on the 16th day of March in the year of the Lord One thousand eight hundred and twenty four Between his Excellency Joseph C. Yates Governor of the State of New York and the Tribe of Indians called Saint Regis Indians by their duly authorized deputies and agents Thomas Williams, Mitchel Cook, Lewis Doublehouse and Peter Turbel. It is covenanted and agreed as follows to wit.—
The said Tribe Indians sell and Do hereby convey to the People of the State of New York all the right title and interest claim and demand whatsoever of in and to All that certain Tract of land in the Town of Massena in the County of St. Lawrence known and distinguished as the Mile Square reserved to the aforesaid Indians with their Mill on Grass River in and by a Treaty Executed on the thirty first day of May in the year of our Lord One thousand Seven hundred and ninety six between the said Indians and Abraham Ogden Commissioner appointed under the authority of the United States and Egbert Bensen, Richard Varick and James Watson Agents of the State of New York and William Constable and Daniel McCormick purchasers under Alexander McComb together with the Mills thereon and all other appurtenances there on to belonging—

In consideration of which promises the said Governor of the State of New York now pays to the said Tribe of Saint Regis Indians the Sum of One thousand nine hundred and twenty Dollars as the Consideration in full for the said track of land with the appurtenances as aforesaid the receipt whereof the said Thomas Williams Michel Cook, Lewis Doublehouse and Peter Turbel the Deputies and Agents of the said Tribe of St. Regis Indians do hereby acknowledge—

In testimony whereof the parties to these presents have hereunto set their hands and seals the day and year first above written.

JOSEPH C. YATES [L.S.]
THOMAS his X mark WILLIAMS [L.S.]
MICHEL his X mark COOK [L.S.]
LEWIS his X mark DOUBLEHOUSE [L.S.]
PETER his X mark TURBEL [L.S.]

Sealed and delivered in the presence of
ELEAZER WILLIAMS
JOHN HADCOCKS

State of New York}
Albany County } *SS.*

Be it remembered that on seventeenth day of March in the year One thousand Eight hundred and twenty four came before me Joseph C. Yates Governor of the State of New York to me known and also Eleazer Williams a subscribing witness to the execution of the within Deed to me also known and thereupon the said Joseph C. Yates duly acknowledged to have executed the within Deed for the uses and purposes therein mentioned and the said Eleazer Williams on his oath says that he saw Thomas Williams Michel Cook Lewis Doublehouse and Peter Turble who are well know to witness execute the within Deed by making their respective marks and that they severally acknowledged to have executed the same for the uses and purposes therein mentioned and that he together with John Hadcock subscribed their names thereto as witnesses at the time of the execution thereof and finding no material alterations or interlineations therein do allow the same to be recorded—

GARRIT V. DENNISTON
Commissioner &c.

Recorded October 20, 1824 and agrees with the Original Compared there with by
ARCHD. CAMPBELL
Dept. Secretary

COPY OF TREATY BETWEEN INDIANS OF ST. REGIS/ AKWESASNE AND STATE OF NEW YORK, SIGNED AT ALBANY ON JUNE 12, 1824[103]

At a Treaty held in the City of Albany the twelfth day of June in the year of our Lord One thousand Eight hundred and twenty four Between his Excellency Joseph C. Yates Governor of the State of New York and Thomas Williams, Mitchel Cook, Lewis Doublehouse, Peter Turbell and Charles Cook, Chiefs and Trustees of the Tribe of Indians called the St. Regis Indians, It is convenated and agreed as follows to wit:

The said Indians sell and hereby convey to the People of the State of New York One thousand acres of land out of the lands reserved by the said Indians to be bounded as follows, On the North East by a line commencing on the Easterly side of the St. Regis River at the termination of the Roll way so called about four or five chains Northerly from the mast road and running thence southeast to the south bounds of the said reserved lands on the south by the said south bounds on the North west by the said St. Regis river and the land leased by the said Indians to Mickael Hogan and on the southwest by a line to be run southeast from the said St. Regis river to the south bounds of said reserved lands so as to comprehend one thousand acres. In consideration whereof the said Governor now pays to the said Chiefs and Trustees one thousand seven hundred and fifty Dollars and covenants on the part of the said People that there shall be further annually paid forever hereafter to the said Indians an annuity of sixty dollars on the first Tuesday of August in each year at the village of Plattsburgh which payments shall be made to the said Chiefs and Trustees and their successors in office duly appointed by the said Indians.

In Testimony Whereof the parties to these presents have hereunto set their hands and seals the day and year first above written
JOSEPH C. YATES [L.S.]
THOMAS WILLIAMS [L.S.]
MITCHEL his X mark COOK [L.S.]

LEWIS DOUBLEHOUSE [L.S.]
PETER TURBELL his X mark [L.S.]
CHARLES his X mark COOK[L.S.]

Sealed and delivered in}
The presence of }
Isaac Denniston
Eleazer Williams
Interpreter -

STATE OF NEW YORK}
Albany County }
On the twelfth day of June one thousand eight hundred and twentyfour came before me Joseph C. Yates one of the parties within named to me known and also Eleazer Williams a subscribing witness to me known and thereupon the said Joseph C. Yates duly acknowledged to have executed the within Deed for the uses and within mentioned the said Eleazer Williams on his oath says that he saw Thomas Williams, Mitchel Cook Lewis Doublehouse, Peter Turbell and Charles Cook severally execute and deliver the within Deed for the uses and purposes within mentioned and that they were all well known to him and that he together with Isaac Denniston subscribed their names thereto as witnesses at the time of the execution thereof - I allow the same to be recorded.

GARRET V. DENNISTON
Commissioner &c.

Recorded October 20, 1824 and agrees with the Original—Compared therewith by
ARCHD CAMPBELL
Dep. Secretary

COPY OF SEALED AGREEMENT BETWEEN INDIANS OF ST. REGIS AND THE STATE OF NEW YORK, SIGNED 14 DECEMBER 1824.[104]

Know all men by these presents that We Thomas Williams Mitchell Cook, Lewis Doublehouse, Peter Tarbell, and Charles Cook Principal Chiefs and head men of the St. Regis tribe of Indians recognized as such by the Governor of the State of New York in the Treaties severally made on the 16th March and 12th June 1824. In Consideration of the sum of One dollar to us in hand paid the receipt whereof we do hereby acknowledge and for and in the further Consideration of the enacting within six months from the date hereof by the Legislature of the State of New York a law providing for the payment annually to us or our successors in office of the sum of three hundred and five dollars have quit claimed granted assigned transferred and set over, and by these presents do in behalf of the said Tribe of St. Regis Indians Quit claim grant assign transfer and set over unto the people of the state of New York forever, all our right title and interest claim and demand soever and to all and singular the premises heretofore granted by our predecessors in office on behalf of our said Tribe to Michael Hogan which premises are fully and at large described in two certain Indentures of lease or Instruments in writing under seal, bearing date respectively on the twentieth & twenty third days of October in the year of our Lord One thousand eight hundred and seventeen, & made and executed by and between our predecessors in office and the said Michael Hogan, and subsequently confirmed by an Act of the Legislature, to which said indentures or Instruments in writing under seal reference is hereby had, to have and to hold the said premises free and discharged of any claim or demand soever of our said Tribe of St. Regis Indians on whose behalf we hereby convey the same forever.

In Witness Whereof We have hereto set our hands and affixed our Seals the fourteenth day of December in the Year of Our Lord one thousand eight hundred and twenty four.

THOMAS his X mark WILLIAMS [L.S.]
MITCHELL his X mark COOK[L.S.]
LEWIS his X mark DOUBLEHOUSE[L.S.]
PETER his X mark TARBELL[L.S.]
CHARLES his X mark COOK[L.S.]

Sealed and delivered in the presence of}
The name "Peter Tarbell" interlined }
1st page between the second & third }
Lines before execution. }
W.L. Gray Jur
John S. Eldridge.-

STATE OF NEW YORK}
Franklin Co. }

Be it remembered that on the third day of January in the year of our Lord one thousand eight hundred and twenty five came before me Thomas Williams, Mitchell Cook, Lewis Doublehouse, Peter Tarbell, Charles Cook to me well known, and executed the within deed as of the date therein mentioned in my presence by making their respective marks and being duly questioned thro their Interpretor Wm. L. Gray severally acknowledged that they execute the same for the uses and purposes therein mentioned, and the said Wm. L. Gray to me also known being duly sworn, on his Oath says, that the purport of said deed was by him fully explained to and understood by said parties executing the same and is in accordance with their request- that having interpreted the same to them, he subscribed his name thereto as Witness to the execution thereof & finding no material interlineations therein I do allow the same to be recorded

JOHN S. ELDRIDGE
Comr.-

No. 51}

STATE OF NEW YORK,}
Franklin County, }
I Asa Wheeler Clerk of the County & Clerk of the Court of the Court of Common Pleas do hereby certify that John S. Eldridge whose name is subscribed to the certificate of the acknowledgment of the annexed Instrument & endorsed thereon was on the day of the date thereof a Commissioner in and for the County aforesaid dwelling in the said County Commissioned and sworn and duly authorized by law to take the proof and acknowledgment of Deeds &c and further that I am acquainted with the hand writing & verily believe that the signature of John S. Eldridge

subscribed to the said Certificate is the proper hand writing of the said Commissioner.-

In Testimony Whereof I have hereunto set my hand and & affixed the seal of the said County this 8th. Day of October 1825.

ASA WHEELER.

Recorded December 30, 1825 and agrees with the original compared therewith by
ARCHD CAMPBELL
Dep. Secretary.

TREATY BETWEEN INDIANS OF ST. REGIS/AKWESASNE AND THE STATE OF NEW YORK, SIGNED AT ALBANY ON SEPTEMBER 23, 1825[105]

At a Treaty held in the City of Albany the twenty third day of September in the Year of Our Lord One thousand Eight hundred and twenty five Between his Excellency DeWitt Clinton Governor of the State of New York and Thomas Williams Mitchel Cook Lewis Doublehouse, Peter Tarbell, Charles Cook Thomas Tarbell Mitchel Tarbell, Louis Tarbell Bettice Tarbell Jarvis Williams and William L. Gray Chiefs and Trustees of the Tribe of Indians called the St. Regis Indians. It is covenanted and agreed as follows to wit.
The said Indians sell and hereby convey to the People of the State of New York out of the lands reserved to the said Indians a Tract bounded as follows to wit: Beginning on the Easterly side of the St. Regis River at the most westerly corner of the lands ceded by said Indians to the People of said State on the twelfth day of June in the year One thousand eight hundred and twenty four and running thence along the last mentioned land south forty five degrees East to the south bounds of the said reserved lands then along the same westerly to the said St. Regis River and then down along the same to the place of beginning, estimated to Contain Eight hundred and forty acres —In consideration whereof the said Governor now pays to the said Chiefs and Trustees the sum of Two thousand one hundred dollars in full for the same—In Testimony whereof the parties to these presents have hereunto set their hands and seals the day and year first above written.

DEWITT CLINTON [L.S.]
THOMAS his X mark WILLIAMS [L.S.]
MITCHEL his X mark COOK [L.S.]
LEWIS his X mark DOUBLEHOUSE [L.S.]
PETER his X mark TURBELL [L.S.]
CHARLES his X mark COOK [L.S.]
THOMAS his X mark TARBELL [L.S.]
MITCHEL his X mark TARBELL [L.S.]
LOUIS his X mark TARBELL [L.S.]
BETTICE his X mark TARBELL [L.S.]
JARVIS his X mark WILLIAMS [L.S.]
WILLIAM L. his X mark GRAY [L.S.]

Sealed and delivered in the presence of
S. DEWITT CLINTON
ISAAC DENNISTON
ISAAC SEYMOUR

STATE OF NEW YORK}
Albany County } *SS.*

Be it remembered that on the twenty third day of September in the year of Our Lord One thousand eight hundred and twenty five before me Garrit V. Denniston one of the Commissioners of the State of New York duly authorized to take the acknowledgment of Deeds &c came DeWitt Clinton Governor of the State of New York to me known and duly acknowledged to have Executed the within Deed for the uses and purposes within mentioned and on the same day also came before me Isaac Seymour One of the subscribing witnesses to the Execution of the within Deed and who has been identified to my Satisfaction by the oath of Isaac Denniston to me Known and thereupon the said Isaac Seymour upon his oath says that he saw Thomas Williams, Mitchel Cook Louis Doublehouse Peter Tarbell Charles Cook Thomas Tarbell Mitchel Tarbell Louis Tarbell Bettice Tarbell Jarvis Williams and William L. Gray who are all known to witness Execute and deliver the within Deed for the uses and purposes within mentioned and that he together with Simeon DeWitt and Isaac Denniston subscribed their names as witnesses to the Execution thereof—I allow the same to be recorded

GARRIT V. DENNISTON Commissioner &c.

Recorded October 25, 1825 and agrees with the original Compared therewith by
ARCHD. CAMPBELL Dep. Secretary.

TREATY BETWEEN INDIANS OF ST. REGIS AND THE STATE OF NEW YORK, FEBRUARY 21, 1845[106]

At a treaty held at the City of Albany on the twenty-first day of February in the year of our Lord one thousand eight hundred and forty five Between the tribe or nation of Indians known by the name of the St. Regis Indians, by their Chiefs and Trustees hereinafter named of the first part and the Commissioners of the Land Office on behalf of the People of the State of New York of the Second part:

Whereas by the act entitled "An Act in relation to certain tribes of Indians" passed May 25, 1841 the Commissioners of the Land Office are authorized to make such treaties contracts and arrangements with any tribe or Nation of Indians or with any parry or portion of them or with any Individual Indian or Indians who have any claim upon any lands in this State for the purchase of any portion of such lands as the said Commissioners may deem just and proper: And Whereas the said St. Regis Indians own certain lands in the County of St. Lawrence known and distinguished as the Indian Meadows or Grass River, on both sides of the said river or as Islands in the said river, which meadows were reserved in and by the Treaty made with the said Indians on the 31ˢᵗ day of May 1796: And Whereas the said Indians are now desirous of ceding and conveying the said Meadows and Islands to the people of the State of New York—It is covenanted and agreed by the said parties as follows to wit:

1. The said Indians hereby cede and convey to the people of the State of New York all their right title and interest of in and to the said Indian Meadows on both sides of the said Grass River or any Islands in the said river in the county aforesaid forever hereafter:

2. In consideration of the cession and conveyance aforesaid the said Commissioners covenant and agree to cause to be paid to the said Indians at and after the rate of three dollars per acre for the said Meadows and Islands as soon as a correct survey thereof can be made in order to ascertain the number of acres therein contained.

3. The said Commissioners covenant and agree to cause the said Meadows and Islands to be accurately Surveyed under the direction of the Surveyor General with as little delay as possible.

4. It appearing by a map made by Amos Lay in the year 1801 now on file in the Surveyor Generals Office that the said Indian Meadows and Islands contain in the whole the quantity of Two hundred and ten acres and four tenths of an acre: It is therefore agreed that the sum of four hundred dollars be now paid to the said Indians and when the Survey aforesaid shall be made and returned to the Surveyor General the remainder of the consideration money at the rate aforesaid shall be paid to them in full.

In Witness Whereof Mitchell Tarbell John Swamp and Thomas Tarbell Chiefs and Trustees and Michael Gaurealt Clerk and Peter Gray Interpreter of the said Tribe or Nation and on behalf thereof have hereunto set their hands and Seals the day and year aforesaid: And the Commissioners of the Land Office of the said State on behalf of the said People have also hereunto subscribed their names on the same day.

MITCHELL his X mark TARBELL [L.S.]
JOHN his X mark SWAMP [L.S.]
THOMAS his X mark TARBELL [L.S.]
MICHAEL his X mark GAREAULT [L.S.]
PETER his X mark GRAY [L.S.]

Signed and Sealed in the}
Presence of }
Isaac Denniston.
A. GARDINER, Lt. Governor
N.S. BENTON, Secy of State
A.C. FLAGG, Comptroller
NATHL JONES, Surveyor Genl.
RENJAMIN ENOS, Treasurer
Comm'rs of the Land Office.

No. 51.}
The foregoing is approved of and ratified by me this twenty first day of February in the year of our Lord One thousand eight hundred and forty five:

In Testimony whereof I have hereunto affixed the Great Seal of the State of State of New York: Witness my hand at the City of Albany on the day aforesaid
SILAS WRIGHT

Examined and Compared with the Original by
ARCHD. CAMPBELL
Dep. Sec. Of State.

NOTES

INTRODUCTION

1. For the full version of this map, go to http://www.sunysb.edu/libmap/ Bressani.htm. (See back cover.)
2. A larger version of the Romer map can be found by going to http://www. sunysb.edu/libmap/Romer.htm.

CHAPTER 1

3. George Washington, *The Writings of George Washington* (Boston: Little, Brown, & Co., 1855), 10:155–6.
4. "The Reply of the President of the United States to the Speech of the Cornplanter, Half-Town, and Great-Tree, Chiefs and Councillors of the Seneca Nation of Indians," December 29, 1790, *American State Papers*, 2, *Indian Affairs* 1:142, http://memory.loc.gov/cgi-bin/ ampage?collId=llsp&fileName=007/llsp007.db&recNum=143.
5. Gustavus Myers, *History of the Supreme Court* (Chicago: Charles Keer & Company, 1912), 116.
6. Jabez Hammond, *The History of the Political Parties in the State of New York* (Buffalo, NY: Phinney & Co., 1850), 57–61.
7. *American State Papers*, 2, *Indian Affairs* 1:585. The entire index for the *American State Papers: Indian Affairs*, vols. 1 and 2, 1789–1827, can be found by going to http://memory.loc.gov/ammem/amlaw/lwsplink.html#anchor2.
8. Ibid., 126–46.

9. Charles J. Kappler, ed., *Indian Affairs: Laws and Treaties*, "Treaty with the Seven Nations of Canada, 1796" (Washington, D.C.: Government Printing Office, 1904), 2:45–6, http://digital.library.okstate.edu/kappler/Vol2/treaties/sev0045.htm.

10. Ibid.

11. Ibid., 50–51.

12. Ibid., "Treaty with the Mohawk, 1797," http://digital.library.okstate.edu/kappler/Vol2/treaties/moh0050.htm.

13. Franklin B. Hough, *A History of St. Lawrence and Franklin Counties, New York* (Albany, NY: Little & Company, 1853), 126. Hough's notation recites: "Copied from a MSS, volume entitled 'Indian Deeds and Treaties, 1712–1810,' in the Office of Secretary of State, at Albany, Page 187."

14. *American State Papers*, 2, *Indian Affairs* 1:616. This can be viewed on the Library of Congress website at http://memory.loc.gov/cgi-bin/ampage?collId=llsp&fileName=007/llsp007.db&recNum=617.

15. *Canadian St. Regis Band of Mohawk Indians v. New York et al.*, 278 F. Supp. 2d 313 (N.D. NY 2003).

16. Deed from the State of New York to Alexander McComb, August 17, 1798. Filed in St. Lawrence County, Liber 1c of deeds, 261–68.

17. Ibid.

18. A copy of the survey of the Macomb purchase can be found in St. Lawrence County clerk's office in the map book called *County Maps*.

CHAPTER 2

19. "Acts Relating to the Indians, and the Lands Occupied by Them (April 10, 1813)," *Consolidated Laws of New York*, §11.29. An act relative to the different tribes and nations of Indians within this state.

20. Public Archives of Canada, Ottawa, Federal Archives Division, RC 10, vol. 717, 162–65. A copy can be found on the microfilm collection *Iroquois Indians: A Documentary History*. An online searchable index can be found at http://microformguides.gale.com/SearchForm.asp.

21. "Treaty Between Indians of St. Regis and the State of New York, Signed at Albany on 15 Mar 1816," *Indian Treaties*, vol. 3, 6–8, New York State Archives, Albany. (See appendix.)

22. "An Act Authorizing the Surveyor General to Lease Certain Lands Belonging to the State, in the St. Regis Reservation (April 3, 1821)," *Consolidated Laws of New York*, §21.245.

23. "Treaty Between Indians of St. Regis and the State of New York, Signed at Albany on 20 Feb 1818," *Indian Treaties*, vol. 3, 21–23, New York State Archives, Albany. (See appendix.)

CHAPTER 3

24. Petition of Indians of St. Regis/Akwesasne. Mentions Treaties with New York State, *Legislative Assembly Papers*, vol. 41, 273–76, New York State Archives, Albany.

25. State of New York Assembly, Report of Special Committee Appointed by the Assembly of 1888 to Investigate the "Indian Problem" of the State, February 1, 1889, 51, 371–72. (Transcript of the appointment of three St. Regis men to act as power of attorney.)

26. Petition of New York State Legislature from Indians of St. Regis/ Akwesasne, Requesting Appointment of Three Men as Trustees, *Legislative Assembly Papers*, vol. 41, 269–70, New York State Archives, Albany.

27. "Treaty Between Indians of St. Regis/Akwesasne and the State of New York, Signed at Albany on 16 Mar 1824," *Indian Treaties*, vol. 8, 40–42, New York State Archives, Albany. (See appendix.)

28. *Journal of the Assembly of the State of New York; at Their Forty-Eighth Session, Begun and Held at the Capitol, in the City of Albany, the 4th Day of January, 1825.* (Albany, NY: E. Croswell, 1825), 724–26.

29. True Copy of Treaty Between Indians of St. Regis/Akwesasne and the State of New York, 16 Mar 1824 (copy was made on April 1, 1824), *Legislative Assembly Papers*, vol. 41, 271–72, New York State Archives, Albany.

30. "Copy of Treaty Between Indians of St. Regis/Akwesasne and the State of New York, 16 Mar 1824 (recorded on October 20, 1824)," *Indian Treaties*, vol. 8, 40–42, New York State Archives, Albany.

31. "Treaty Between Indians of St. Regis/Akwesasne and the State of New York, Signed at Albany on 12 June 1824," *Indian Treaties*, vol. 3, 46–47, New York State Archives, Albany. (See appendix.)

32. "Treaty Between Indians of St. Regis/Akwesasne and the State of New York, Signed at Albany on 14 Dec 1824," *Indian Treaties*, vol. 3, 47–49, New York State Archives, Albany. (See appendix.)

CHAPTER 4

33. Recorded on August 13, 1825, in Liber 3 of Deeds, 24–5, in the Franklin County clerk's office.

34. An Act to Enable Certain Persons Therein Named, to Purchase and Hold Real Estates within This State (April 7, 1806), *Consolidated Laws of New York*, 165. As for the act from March 1806, I found no reference to Michael Hogan, ferries or anything in the Hogansburg area for March 1806. There is an act from April 1806 giving Michael Hogan, his heirs and others named (indexed under Aliens) the right to lease or own property in New York State.

35. An Act for the Benefit of the St. Regis Indians (March 26, 1802), *Consolidated Laws of New York*, 50.

36. Recorded on August 13, 1825, in Liber 3 of Deeds, 31–32, in the Franklin County clerk's office.

37. Recorded on September 21, 1825, in Liber 3 of Deeds, 81–85, in the Franklin County clerk's office.

38. The survey map can be viewed by going to http://digitalcollections. archives.nysed.gov/index.php/Detail/Object/Show/object_ id/36814.

39. *United States v. Franklin County*, 50 F. Supp. 152 (N.D. NY 1943).

40. *Canadian St. Regis Band of Mohawk Indians v. New York*, 146 F. Supp. 2d 170 (N.D. NY 2001).

CHAPTER 5

41. Recorded on in Liber 9 of Deeds, 466, in the St. Lawrence County clerk's office.

42. "Treaty Between Indians of St. Regis/Akwesasne and the State of New York, Signed at Albany on 23 Sept. 1825," *Indian Treaties*, vol. 3, 51–52, New York State Archives, Albany.

CHAPTER 6

43. State of New York Assembly, Report of Special Committee Appointed by the Assembly of 1888 to Investigate the "Indian Problem" of the State, February 1, 1889, 51, 371–72. (Treaty between the St. Regis Indians and the State of New York, 1845.)

44. L.H. Everts and J.M. Holcomb, *History of St. Lawrence County, New York, 1749–1878* (Philadelphia: L.H. Everts & Co., 1878), 63.

45. John W. Edmonds, ed., *Statutes at Large of the State of New York, Comprising Revised Statutes, as They Existed on the 1ˢᵗ Day of July, 1862, and All the Public Statutes then in Force*, vol. 4 (Albany, NY: Weare C. Little, Law Bookseller, 1863), 371.

CHAPTER 7

46. Kappler, *Indian Affairs*, "Treaty with Six Nations, 1784," 2:5–6.

47. Fort Stanwix Treaty, 1784, http://digital.library.okstate.edu/kappler/ Vol2/treaties/nat0005.htm.

48. Kappler, *Indian Affairs*, "Treaty with Six Nations, 1789," 2:23–25.

49. Kappler, *Indian Affairs*, "Treaty at Fort Harmar, 1789," 2, http://digital. library.okstate.edu/kappler/Vol2/treaties/six0023.htm.

50. State of New York, Report of the Regents of the University of the Boundaries of the State of New York (Albany, NY: Argus Company, 1874), 216–23.

51. *Journals of the Continental Congress, 1774–1789*, vol. 33, 617–29.

52. *Debates and Proceedings in the Congress of the United States. Second Congress. Comprising the Period from October 24, 1791 to March 2, 1793, Inclusive.* (Washington, D.C.: Gale and Seaton, 1849), 210–15.

53. State of New York, *Report of the Regents of the University of the Boundaries of the State of New York* (Albany, NY: Argus Company, 1874), 305–6.

54. Kappler, *Indian Affairs*, "Treaty with the Six Nations, 1794 (Canandaigua)," 2:34–7. http://digital.library.okstate.edu/kappler/ Vol2/treaties/six0034.htm.

55. Ibid.

CHAPTER 8

56. Reverend Timothy Alden, *Account of Sundry Missions Performed Among the Senecas and Munsees in a Series of Letters* (New York: J. Seymour, 1827), 110–17.

57. Kappler, *Indian Affairs*, "Agreement with the Seneca, 1797," 2:1027–30.

58. Ibid.

59. Kappler, *Indian Affairs*, "Treaty with the Seneca, 1802," 2:60–61, http:// digital.library.okstate.edu/kappler/Vol2/treaties/sen0060.htm.

60. Chiefs and Warriors of the Seneca Nation of Indians to William Willink et al., via their agent and attorney Joseph Ellicott, Liber 1 of Deeds, 58, in the Genesee County clerk's office, June 13, 1802, recorded on November 5, 1804.

61. Chief Warriors and Chief Sachems of the Seneca Nation to Mary Jemison, Liber 5 of Deeds, 355–56, Ontario County clerk's office (now held at the Ontario County Archives). Dated 1797, recorded on October 13, 1798.

62. http://digitalcollections.archives.nysed.gov.

63. Mary Jameson to Micah Brooks and Jellis Clute, Liber 10 of Deeds, 5–6, Genesee County clerk's office, April 23, 1817, recorded on April 26, 1817. Witnessed by George Jameson, Azel Lyon and Thomas Clute.

64. Mary Jameson to George Jameson, Liber 12 of Deeds, 253, Genesee County clerk's office, January 12, 1819, recorded on April 5, 1819.

65. Joseph Higbee, Trustee to Henry B. Gibson, Liber 2 of Deeds, 131–32, Livingston County clerk's office, June 18, 1823, recorded on July 21, 1823.

66. Kappler, *Indian Affairs*, "Agreement with the Seneca, 1823," 2:305.
67. Ibid.
68. The original will is long missing from the probate file of Mary Jemison filed in the Erie County Surrogate Court, file 11192. The only will in the file is the one submitted by her daughter Polly when she contested the will presented. However, the original is recorded in Liber 2 of Wills, 102–9. One of the rare original copies is in the museum at Letchworth State Park.
69. Lockwood R. Doty, *A History of Livingston County, New York* (Jackson, MI: W.J. VanDusen, 1905), lxxvi–lxxix, http://www.letchworthparkhistory.com/buffalocreek1826.html.
70. Liber 10 of Deeds, 138–41, Erie County clerk's office, recorded on May 16, 1827.
71. House of Representatives. Mary Jemison—Heirs of, 36th Congress, 1st Session, Report No. 254.

CHAPTER 9

72. Kappler, *Indian Affairs*, "Treaty with the New York Indians, 1838," 2:502–16.
73. Buffalo Creek Treaty, 1838, http://digital.library.okstate.edu/kappler/Vol2/treaties/new0502.htm.

CHAPTER 10

74. *Collections of the State Historical Society of Wisconsin* (Madison, WI: Democrat Printing Company, 1900), 15:20–24, 405–10.

CHAPTER 11

75. *American State Papers*, 2, *Indian Affairs* 2:699.
76. Ibid., 699–702.
77. If you would like to read more of "Emigration of the Indians West of the Mississippi," you can find it by going to http://memory.loc.gov/cgi-bin/ampage?collId=llsp&fileName=008/llsp008.db&recNum=706.

NOTES TO PAGES 135–150

CHAPTER 14

78. *Journal of the Executive Proceedings of the Senate of the United States of America,1837–1841,* January 14, 1840.
79. Kappler, *Indian Affairs,* "Treaty with the Seneca, 1842," 2:537–42.
80. Kappler, *Indian Affairs*, "Compromise Treaty of 1842," 2, http://digital. library.okstate.edu/kappler/Vol2/treaties/sen0537.htm.
81. Kappler, *Indian Affairs*, "Treaty with the Seneca Tonawanda Band, 1857," 2:767–71.
82. Kappler, *Indian Affairs*, "Treaty with the Seneca Tonawanda Band, 1857," 2, http://digital.library.okstate.edu/kappler/Vol2/treaties/sen0767.htm.

CHAPTER 15

83. *New York State Statutes at Large*, vol. 5, 612.
84. James K. Polk, *The Diary of James K. Polk during His Presidency, 1845 to 1849* (Chicago: A.C. McClurg & Co., 1910), 25.
85. Doty, *History of Livingston County.*
86. T.F. Robley, *The History of Bourbon County, Kansas: To the Close of 1865* (Fort Scott, KS: Monitor Book & Print Co., 1894).

CHAPTER 16

87. Map Book 8, 389, Genesee County clerk's office.
88. Ibid., Liber 146 of Deeds, 82.
89. George J. Bryan, *Biographies of Attorney General George P. Barker, John C. Lord D.D., Mrs. John C. Lord, and William G. Bryan, Esq.* (Buffalo, NY: Courier Company, 1886), 165–71.

CHAPTER 17

90. You can look at the actual list of the thirty-two occupants by going to http://www.territorialkansasonline.org/ and typing in "New York Indians" in the search box.

CHAPTER 18

91. This report can be viewed in its original form by going to Territorial Kansas Online at http://www.territorialkansasonline.org/ and typing in "Michael Gray" in the search engine. It is transcribed for you here, complete with any spelling errors in order to maintain the integrity of the document.

195

CHAPTER 19

92. House of Representatives, 42nd Congress, 2nd Session, HR872.

CHAPTER 20

93. 52nd Congress, 1st Session, Report 1858.
94. Passed by an Act of Congress on January 28, 1893, c. 52, 27 Stat. 426.
95. *Post Standard*, August 24, 1905.
96. Ibid., October 3, 1905.
97. Ibid., September 30, 1905.

APPENDIX

98. *Indian Treaties*, vol. 3, 6–8, New York State Archives, Albany.
99. Ibid, 21–23.
100. State of New York Assembly, Report of Special Committee Appointed by the Assembly of 1888 to Investigate the "Indian Problem" of the State, February 1, 1889, 51, 371–72.
101. *Legislative Assembly Papers*, vol. 41, 271–72, New York State Archives, Albany. Copy was made on April 1, 1824.
102. *Indian Treaties*, vol. 8, 40–42, New York State Archives, Albany. Recorded on October 20, 1824.
103. *Indian Treaties*, vol. 3, 46–47, New York State Archives, Albany.
104. *Indian Treaties*, vol. 3, 47–49, New York State Archives, Albany. This conveys the ferry to Michael Hogan.
105. *Indian Treaties*, vol. 3, 51–52, New York State Archives, Albany.
106. State of New York Assembly, Report of Special Committee Appointed by the Assembly of 1888 to Investigate the "Indian Problem" of the State, February 1, 1889, 51, 379–81.

BIBLIOGRAPHY

Y ou can read the digitized reprint of the original "Have We a Bourbon Among Us?," as well as another article titled "The Last of the Bourbon Story," online by going to http://cdl.library.cornell.edu/moa/ and typing in "Lost Dauphin" in the search engine.

OTHER SOURCES

Hanson, J.H. *The Lost Prince: Facts Tending to Prove the Identity of Louis the Seventeenth, of France, and the Rev. Eleazar Williams, Missionary Among the Indians of North America.* New York, 1854.

Wisconsin Historical Society. Online collection of local history and biography articles on Eleazer Williams. http://www.wisconsinhistory. org/odd/archives/001202.asp.

Wright, William Ward. "Eleazer Williams: Not the Dauphin of France." Lecture, 1903. Williams family papers, Neville Museum, Green Bay, Wisconsin.

INDEX

ABOUT THE AUTHOR

Cindy Amrhein was the historian for the town of Alabama, New York, from 1997 to 2007. Cindy became fascinated with the town's history when she moved to the area in 1990. She wrote her first book, *Bread & Butter: The Murders of Polly Frisch*, published in 2000, with her good friend Ellen Lea Bachorski. The story has been given a new life by publishing a revised, updated second edition in 2014. She also served as a museum aide at the Holland Land Office Museum in Batavia, New York.

After working for ten years as a freelance abstractor for a title search company, Cindy changed her focus to title searching only historic properties and Native American land. From 2004 to 2006, Cindy was a weekly columnist for a Native American newspaper in northern New York State, the *Akwesasne Phoenix Sundays* (now out

Photo by Jennifer Claud.

of print) under the pen name of HistorySleuth, the handle she still uses online.

Cindy now lives in Wyoming County, New York, where she had been the assistant county historian since 2007 and recently became the county historian in June 2015. She frequently publishes in the historian's office quarterly *Historical Wyoming*. She is a founding member of the Government Appointed Historians of Western New York. When she's not doing land research in the clerk's office or writing historical true crime, you can find her plotting out murder mysteries. She often posts snippets of her current writing on her blog at http://historysleuth.blogspot.com.